PRIDE

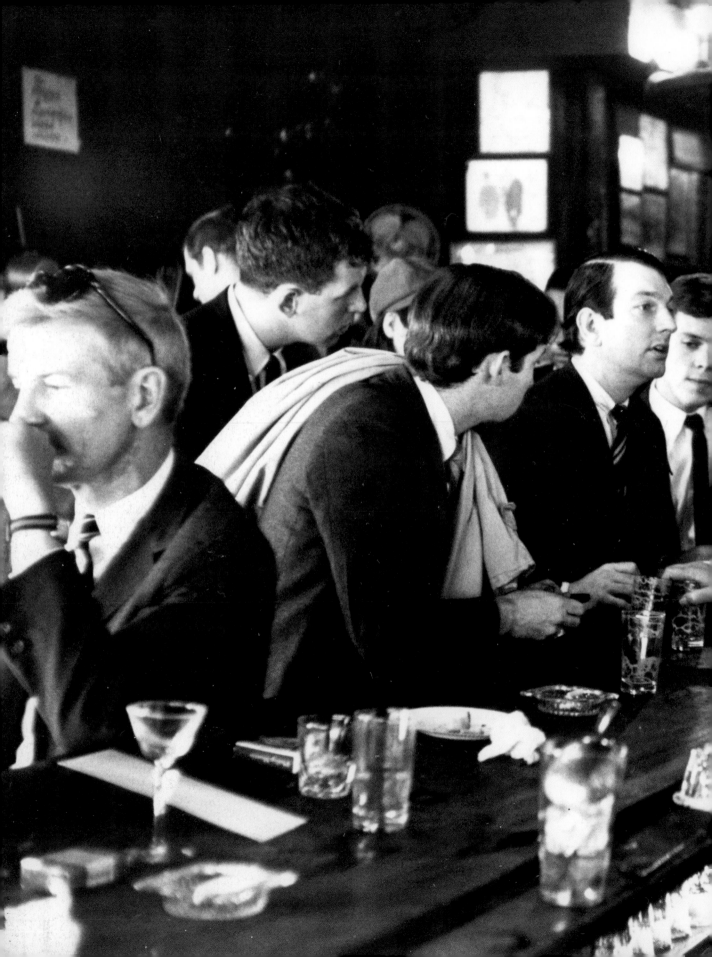

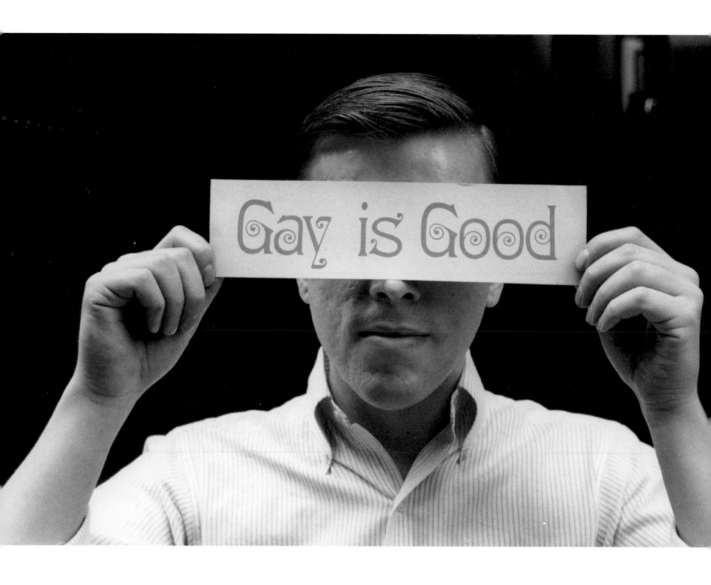

PRIDE

PHOTOGRAPHS AFTER STONEWALL

FRED W. McDARRAH

WITH A FOREWORD BY HILTON ALS

AND INTRODUCTIONS BY Allen Ginsberg
AND Jill Johnston

OR Books

New York • London

© 1994, 2019 Estate of Fred W. McDarrah
Foreword © 2019 Hilton Als
Published by OR Books, New York and London
Visit our website at www.orbooks.com

Photographs: Fred W. McDarrah
Editor and writer: Timothy McDarrah
Assistant editor: Theodore McDarrah

All rights information: rights@orbooks.com

First trade printing 2019

Library of Congress Cataloging-in-Publication Data: A catalog record for this book is available from the Library of Congress. British Library Cataloging in Publication Data: A catalog record for this book is available from the British Library.

Pages 2–3: On April 21, 1966, members of the Mattachine Society staged a "sip-in" at Julius' Bar, 159 W. 10th Street, demanding that, as open homosexuals, they be served. Liquor laws at the time forbade this. Julius' later became a gay bar. L to R: John Timmins, Dick Leitsch, Craig Rodwell, Randy Wicker.

Page 4: Craig Rodwell, founder, Oscar Wilde Bookstore, October 14, 1969.

Designed and typeset by Laura Lindgren

Published by OR Books in partnership with Counterpoint Press. Distributed to the trade by Publishers Group West.

paperback ISBN 978-1-949017-11-3 • ebook ISBN 978-1-949017-12-0

Contents

A NOTE ON THIS BOOK'S PUBLICATION

This book was originally published in 1994, on the twenty-fifth anniversary of Stonewall, with the title *Gay Pride: Photographs from Stonewall to Today*. Times change, and "gay" is no longer the accepted umbrella term for all people not straight. Hence, this edition, published to mark the fiftieth anniversary of Stonewall, has a slightly different title from the original publication. We added some previously unpublished pictures, too.

The reception to the original book, from potential publishers, book stores and the buying public, was not strong. It was in many ways a political statement at the time for its author and editor just to openly publish and proudly market a gay-themed photo book with a bright pink cover.

Fifteen years after this book was first published, in 2009, the Oscar Wilde Memorial Bookshop—the world's first outlet for predominantly gay literature—closed. But it was not an altogether sad event, as it meant that "gay" literature was out of the closet and part of mainstream commerce.

There has been a world of progress since Stonewall, and since the 1994 edition of this book, including in the marketplace. For this edition, publishers were vying for it and bookstores will openly display it. And hopefully plenty of people will buy it!

A few people who must be recognized before the photos start:

Hilton Als, Fred W. McDarrah's onetime Village Voice photo desk assistant, for his gracious introduction to this volume; Patrick J. McDarrah, for having the original idea for this book; Theodore H. McDarrah for his contributions to this edition; and Gloria S. McDarrah, the keeper of the photo flame as the thoughtful and forward-thinking executrix of the Estate of Fred W. McDarrah.

Three generations of straight—but not narrow—McDarrahs doing our little part for the greater good.

We'd like to thank the team at OR Books—John Oakes, Colin Robinson, Emma Ingrisani, and Emily Freyer—for their commitment to make this book that you are now holding in your hands as terrific as it is. We are deeply appreciative of the work of Laura Lindgren, who is responsible for the creative and sensitive redesign and type-setting of *Pride*.

Most importantly, we'd like to thank everyone in the photos and their brethren over the decades who are not in the photos, for their determination and perseverance and ceaseless efforts in the struggle for equality.

This book would not be possible without them.

<div align="right">

–Timothy S. McDarrah
January 2019
Greenwich Village

</div>

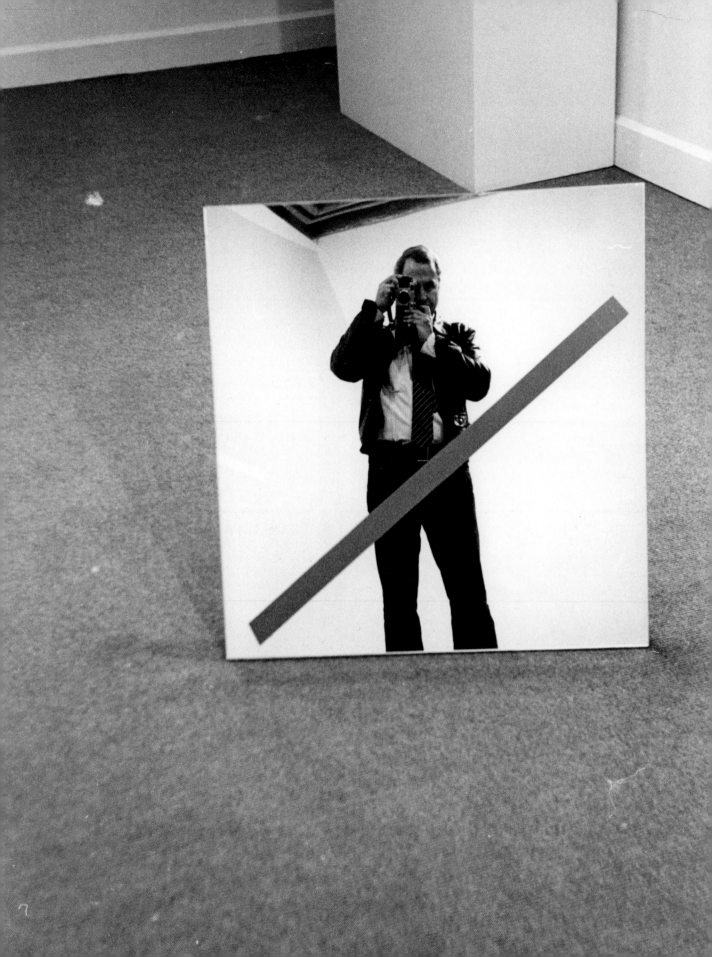

FOREWORD Hilton Als

It is a dubious honor to write about Fred—dubious because I don't want him to be gone. I'd rather write about the work he would still be doing now if he were around, covering his territory, which is to say Manhattan, specifically downtown New York, which, if you squint, you can still see through his eyes. But you have to squint hard. Fred's downtown had nothing to do with chain stores and corporate raiders and their kind. His pictures showed a maze of streets and ideas snaking their way down to the Hudson River, or the East River, streets filled with so many stories that I see in black and white, still, because of Fred's pictures, which also show stretches of unaccounted-for space, like some movie version of the West. But that was long ago, before Fred's Manhattan started to heave at its center as it struggled to contain many people and institutions that would have disturbed Fred, that wanderer who loved New York, but a New York based on creativity and freedom rather than commerce.

Fred was an urban cowboy. He wore beautifully shaped and well-cared-for cowboy boots. The boots were part of his habitual outfit: blue jeans and meticulously cared-for denim shirt—the neat and efficient costume of the dedicated working man. In the winter, sometimes, Fred wore a leather jacket or a denim jacket to complete this look, but mostly when I think of Fred it's him taking his jacket off and rolling up his sleeves to get to work as *The Village Voice*'s first-ever picture editor and staff photographer. (I succeeded Fred in the picture editor job, a transition that was not as difficult as you might think. That I was ever his "boss" is a ridiculous notion. No one is ever the boss of history, the living history you want to learn from.)

Fred covered everything, but he first became known for capturing the Beat scene at its New York start. It was a new world, then filled with that era's youth, all those cigarettes and tough attitudes

Fred W. McDarrah takes a self-portrait in a mirror that forms part of Buky Schwartz's installation "In Real Time," on display during the Whitney Biennial, New York, February 4, 1981. (Photo by Fred W. McDarrah)

that were out of step but somehow OK with the immigrant families who raised their kids in the tenements near the Café Wha? and what not. Those immigrant families cooled themselves on stoops in the summer as those Beat youths, resplendent in jeans and circle shirts, rushed the avenues in pursuit of another hootenanny, intent on getting everywhere fast, following sounds. Fred saw the artists who helped define the time—Jack Kerouac and Bob Dylan—poets scratching lyrics and stories out of the New York air.

What always struck me about Fred's early black-and-white pictures, too, is how verbal they feel to me, not in the corny sense that every picture tells a story; no, what we see in so many of the pictures from that time are people talking and telling stories, a fusillade of words caught in space, ideas and jokes that may come to nothing, or everything. The point is, one of the great things Fred captured in his historic early work is an exchange of ideas among those who were shaped by thinking, and by art, the belief that if not all of the world's problems could be solved in conversation, then they could be exhumed and examined.

Fred was born in a hard place. His father, a depressive, was barely able to function, and so the care of the family fell to Fred and his brother early on. Whenever he talked about his youth, or his father in particular, a shadow crossed his face; it's the only time I ever saw Fred remotely unhappy. He never elaborated on where he was raised, and you knew not to ask: the pain in his eyes was real and deep and fresh.

Part of Fred's drive—isn't it everyone's?—was to provide for his children; work meant family and safety, and the other thing I found interesting in many of Fred's pictures before and after he started a family with his wife, Gloria, is how interested the photographer was in New York's improvised families, how we Manhattanites take up with one another and forge living and uncomfortable bonds that last for a night, or forever. I think those alliances are at the heart of Fred's pictures of gay life in our city's pre- and post-Stonewall days, when things were on the verge of change, and they did change. And of course Fred was there, at the very start of a movement that became a movement when queer people were pushed to the wall that historic night on Christopher Street at the Stonewall. Fred saw it all and recorded it all: the young queer people who were tired of being

told that their way of being was obscene, that the families they'd made were twisted, all those folks who had been told year after year and all their lives that they were wrong.

The Stonewall—the safety of a gay bar—was a small thing to ask after having come up with no safety at all, and I wonder if Fred—because of his upbringing—understood that. He must have, because he was always drawn to people who didn't have a lot, but made a lot with what they had. His portrait of Candy Darling, the trans performer, is one of the greatest comments we have not only on transformation but on stillness—a moment of reflection during an era when stillness was not the point but change was. I think I first saw Fred's pictures of Manhattan's gay denizens, the protestors fighting for change, fighting to be themselves, at the Oscar Wilde Bookstore, on Christopher Street. That store is gone now, but it stood for so much during its time: another place of safety, filled with information about who we were, and who we would be. As inclusive as New York can be, it is also a segregated city, but I never felt like a divided self at the Oscar Wilde; I felt lucky to enter its doors and see the latest Tennessee Williams, or books by writers like David Leavitt, writers who trafficked in memory and the present (both of whom Fred had photographed, of course). This would have been in the early nineteen-eighties, when I was barely a self, but anxious to join all those bodies, glitter, voices, agents of change that Fred, an agent of change himself, recorded with nothing less than love and respect, the same love and respect many of us had for Fred who, lifting his camera, saw the person before he saw anything else.

<div style="text-align: right;">

January 2019
New York City

</div>

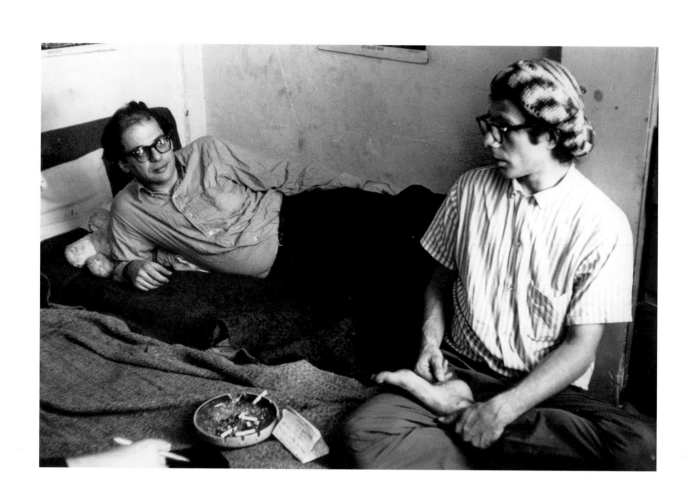

McDARRAH'S PARADES Allen Ginsberg

As friend, cultural co-worker and sometime subject of Fred McDarrah and his neighborly camera I've marveled his historic constancy, decades of endurance. He's a working photographer like his eccentric Manhattan predecessor, the illustrious news pix artist, Weejee. For the *Village Voice* (radically bohemian in its first decades), McDarrah in place focused his camera at cultural action in Manhattan hot spots—especially Greenwich Village, migrations of underground arts to Lower East Side (later commercially renamed "East Village"), & on transformations of Soho loft and gallery society.

This happened over half a century, McDarrah present, his camera flashing thru 1950s nascent subterranean counter-culture, the mind-altering youth culture of the 1960s, Government blockades & psychic disillusionments of the '70s, desperate upwardly-mobile graspings for personal safety in 1980s, and return to sane tragic Earth beginning 1990s. McDarrah's photographs present a classic spectrum of themes parallel to alteration of U.S. consciousness—Anarchist street action, art openings, poetry readings, Living Theater, race drama, political spectacles, presidential conventions, folk music years, police riots, drug tribulations, underground cinema days, rock and roll studios and these Gay Liberation parades.

He's paid humble attention year after year to his beat—curious intersection of journeymen journalist & cultural archivist. He has soulful instinct for human ground under his special subjects. Though not gay, a hard-laboring family man himself, he's made photo records of gay parades for decades—sign of a real artist's inquisitive sympathy, intelligent democracy.

Think of the historic importance of coming out of the closet! Stonewall's cry echoed round the world! Spiritual liberation meant

Allen Ginsberg and Peter Orlovsky in their East Village apartment, November 1, 1964.

gay liberation also, the liberation of individual veracity against hypocrisies of church, state, and age-old social sadism. A revelation of actuality in the midst of mental hallucination and emotional repression. Truth against "lies, age-old, age-thick."

What was the fix to begin with? Legendary gay bars owned by organized crime paid off the New York police, and if they didn't they were closed down. Something went wrong with the payoffs at Stonewall Inn. So the customary repression of gay social life was motiv'd by hypocritical greed & sadism. As the sign says:

"GAY PROHIBITION CORRUPT\$ COP\$ AND FEED\$ MAFIA"

Who rebelled against this police fraud? We see hairy-chested guys with leather caps like cops, curbstone pixies on roller-skates applauding the parade, white-clad pure butch lesbians, poseurs mugging in front of Stonewall's grafitti'd facade, "Gay Cruise" billboards above Christopher Street's classic, cigar-store corner, Rock Hudson elegies & T-shirt sociologies on Keith Haring's shop wall, a gay vet tombstone, Carmen Miranda banana hat clones, transvestite motorcyclists, brown skins dancing, AIDS Die-ins, Peter Orlovsky & myself musing in bed, arm in arm old lovers bald, Baldwin & marble Lincoln, Auden's wrinkle-faced dignity, Gay Liz comix covers, thirtysomething male hands sharing Affidavits of Domestic Partnership, magic homosex symbols flagged above Grove Street's old brick roadway, a limp protester dragged off by cops, a "Love Boys" spray-painted door, bath-house queens and bare chest youthful cuties, Priests & Amazons, campy mitered Bishops & Gay Church floats, 1973 night crowds and balloons, Stonewall Inn shut down, a sign for "Bagels And" above its old brick front.

These anniversary parades, and records thereof like Fred McDarrah's, are now significant as we approach end of millennium. Think of present circumstances—recent revelation of the tortured & torturing blackmail psyche of the mad transvestite J. Edgar Hoover in the closet—the late powerful homophobe N.Y. Cardinal Francis Spellman dallying with Broadway chorus boys on the privacy of citizen Roy Cohn's yacht! Roy Cohn himself a tax-free anti faggot power head queer lawyer for the N.Y. Diocese, organized crime hats, androgynous politicians & macho millionaires, gay pimp for the

Director of the F.B.I. How many magic Cardinals & religious fanatic priests we see unmasked, their tenderest longings hid under the iron visage of censoriousness.

This year Cardinal Spellman's successor Cardinal O'Connor still dares to put his Biblic curse on gays, no public word whispered of his famous predecessor's celebrated predilection for young men's love. Thus while Catholic Ireland herself, through miraculous legislation, presently legitimizes homosexuality, the New York Cardinal scandalously's prohibited Irish gay brigades from marching with the Green on St. Patrick's Day parades!

This degraded "Family Values" theopolitics has become a worldwide mask for mind control against spiritual liberation. Hear the late Khomeini Ayatollah and his successor little Satans denounce "Spiritual Corruption," along with Stalin, Mao & Hitler. Listen to Pat Robertson his confrères & his guru W.A. Criswell, the fundamentalist Svengali of a "Biblical Inerrancy" cult, intolerant of any deviance from mind control by their interpretation of the "Good Book."

These vicious priesthoods are allied with beer magnates and tobacco Senators in hierarchies of political ambition, demagoguery, power addiction, nationalist chauvinism, military aggression, assassinations and war. Intolerant of other faiths, sexualities and folkways! Fraudulent ethical poseurs set family members against each other, & oppose ancient true family values of sympathy, tolerance, forgiveness, intimacy, humor and fidelity.

Fred McDarrah's views of the Stonewall parades present these true human values. Here we have the onlooker's inquisitiveness—what a citizen of Manhattan might see over a period of years—gay character epiphanies—A nation in spiritual transformation.

<div align="right">November 15, 1993
Paris</div>

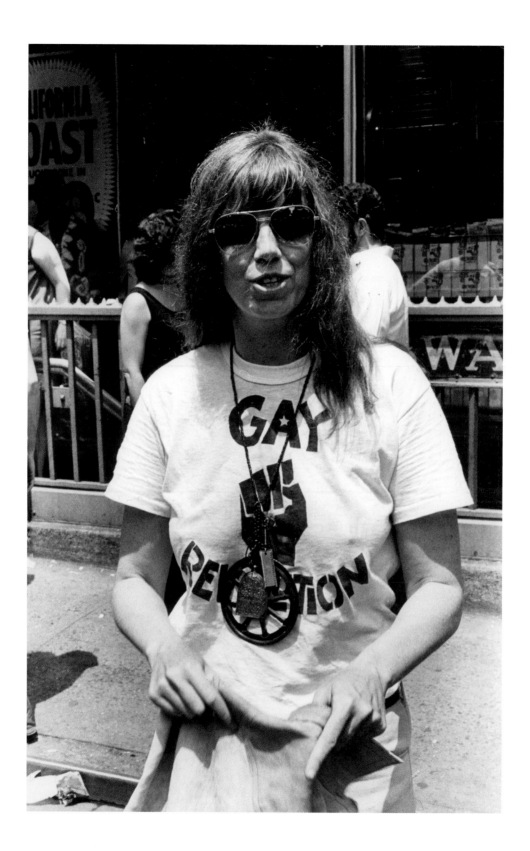

FIRESTORM ON
CHRISTOPHER STREET Jill Johnston

The uprising of lesbians and gay men in late June-early July 1969
on the streets outside the Stonewall bar in Greenwich Village marks
a great watershed moment in both cultural history and the lives of
many citizens. I think of Stonewall myself as an event dividing time
in B.C. (before consciousness) and A.D. (after death–of the life before
consciousness). It was the event that catalyzed the modern gay and
lesbian political movement. It changed the way thousands, ulti-
mately millions, of men and women thought of themselves. It des-
ignated the beginning of the possibility of integrated lives for those
who had lived divided against themselves–split between who they
really were and what they knew they were supposed to be, between
what they did and how they felt and what they said. It represented
the birth of an identity unprecedented in society. Stonewall, we can
see now, was surely inevitable, the launching of the last revolution
in a decade of civil disruptions by all disadvantaged minorities for
rights and visibility.

The foundation for the Stonewall riots had been laid by the sec-
ond wave of feminism, which gathered momentum in the late '60s,
and the small but growing homophile movement of the '50s and
'60s. Pockets of resistance preceded Stonewall. As the general mood
of antiwar and civil rights insurgents turned mean and violent
in 1968, with the assassinations of Robert F. Kennedy and Martin
Luther King, Jr., the frustrations over Vietnam, the intransigence
of government, the suppression of the Black Power movement
through harassment, beatings, and jailings, and the cumulative rage
of activist women, the possibility existed of a firestorm occurring
if a single lit match was thrown into any urban location where

Jill Johnston, author of *Lesbian Nation,* at the Gay Pride March, June 27, 1971.

homosexuals lived. That location tuned out to be the Stonewall Inn, a gay bar that had regularly been raided by the police.

The night of June 27, 1969, for reasons that remain historically inexplicable, a small crowd on the street outside the Stonewall Inn that gathered while a police raid was in progress not only refused to disperse as it usually did, but grew in numbers, and in anger, until an accumulation of small violent incidents—confrontations between police and patrons—caused the crowd to erupt in a mass action against its agents of oppression.

I happened to be in Europe at that moment, returning to New York in August. By November, I was introduced to Jim Fouratt and Lois Hart, both leaders of the new Gay Liberation Front (GLF) that had formed in the wake of Stonewall. Lois Hart and her activist friends had detected submerged lesbian ramblings in my *Village Voice* column. Indeed, since the fall of 1968 I had been writing of my travels with a young woman with the urgency and desperation of one both in love and in fear of the normal disastrous outcome for such relationships. By the time the GLF found me, I was sustaining the enraged chemistry that is thought to make a person predisposed to revolutionary ideas. Nonetheless, I was not an instant convert.

Until this time, I had lived in a state grandly oblivious to all forms of politics. I had the well-known resistance associated with assumed privileges. I had not had an easy life, but had been making my way creatively in the art world—traditionally itself a bastion against politics—for a dozen years. In 1969, I was even less conscious of being a woman than I was of my emotional/sexual identity. But once I "got it," nobody could have been more turbulently wrathful than I was— possibly because I was so belatedly political, pushing forty already. An extensive past of my own collusiveness in my devastations as a woman and a lesbian washed over me in great waves of disgust and disbelief.

Now, in the 1990s, we can look back at our progress and setbacks over the years. This book is a testimony to a moment in time that we regard with the awe, the historicity, of an ancestral totem. Stonewall was not an event without a background, but it established the basic tenets of our revolution. Thereafter, no accommodations were to be made to the judges of our "condition," particularly of course the psychiatrists, or to the ban on visibility or self-identification that

had existed forever so far as we knew. A legitimate minority had arisen, taking its place amongst women, blacks, the poor, the aged, the young, and the animals. The struggle for civil rights began right then, and continues now, in a still-hostile environment, with populations still largely determined to deny homosexuals their identity.

I see lesbians especially beleaguered in this struggle, stuck as they have been in a kind of no-man's-land between the feminists and gay men, with vital interests aligning them to each group, and with naturally the least visibility. The fortunes of lesbians since 1969 have thrown them most persuasively together with gay men in common cause. It's unfortunate, as I see it, that the lesbian constituency has not emerged as a perceived leadership of the women's movement. This is one of my hopes for the future.

I see decades of contest for recognition and rights, often making me wish I could be thawed out at some future glorious time of true liberation.

November 15, 1993
New York City

PRIDE

PHOTOGRAPHS

BEFORE STONEWALL

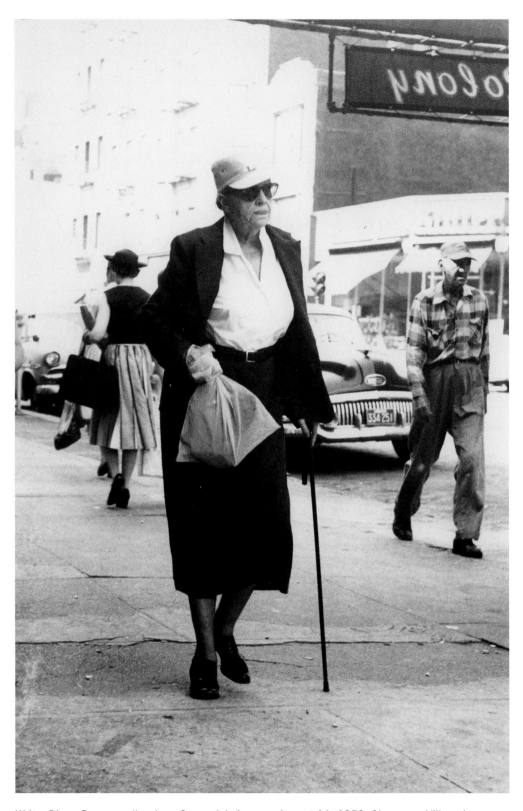

Writer Djuna Barnes walks along Greenwich Avenue, August 14, 1959. She was a Village icon, best known for her novel *Nightwood*, a classic of lesbian fiction and modernist literature.

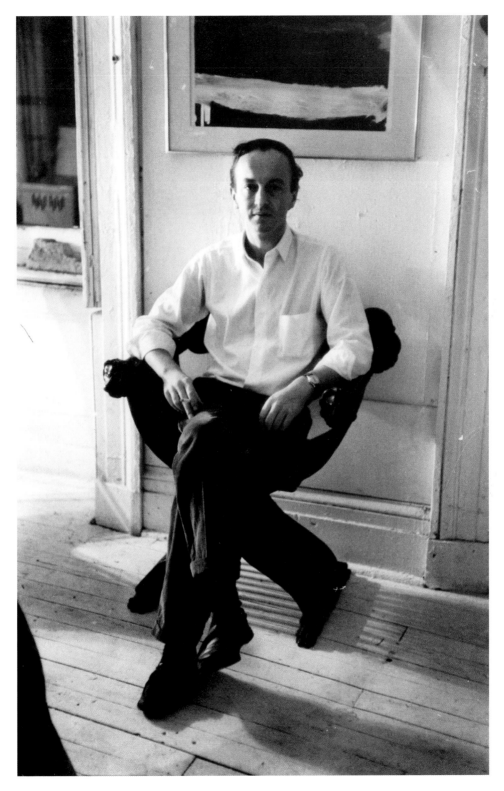

Poet and Museum of Modern Art curator Frank O'Hara in his apartment on September 26, 1959. Because he wrote openly gay love poems, O'Hara was revered by the gay political movement of the 1970s.

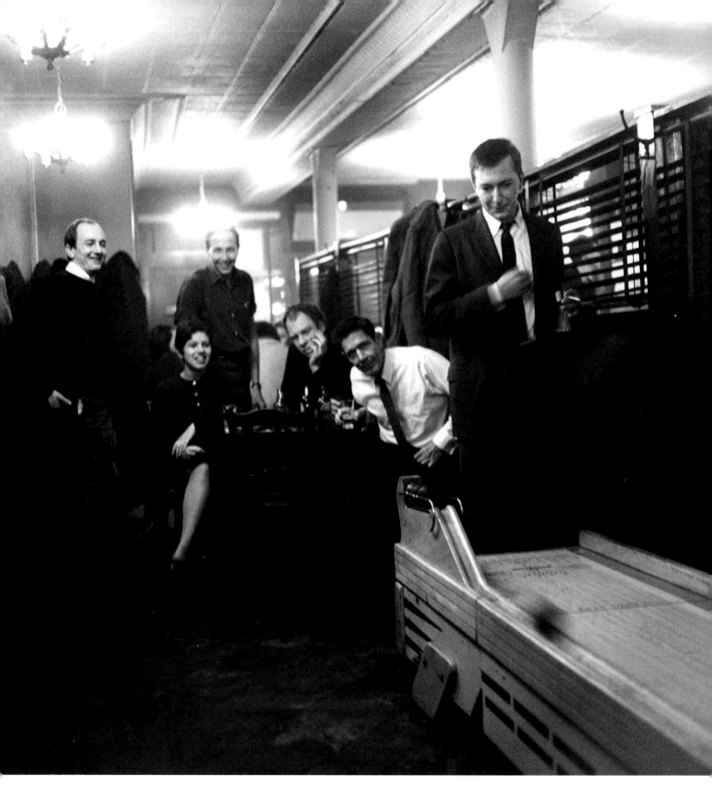

From left, artists William Giles, Anna Moreska, Robert Rauschenberg, dancer-choreographer Merce Cunningham, and composer John Cage watch artist Jasper Johns play Skee-Ball at Dillon's Bar, 80 University Place, November 10, 1969. Cunningham and Cage were lovers for nearly half a century, as were Rauschenberg and Johns during the fifties. Along with the Cedar Tavern, Dillon's was a major artists' hangout of the era. In the 1970s, the building housed the offices of the *Village Voice*.

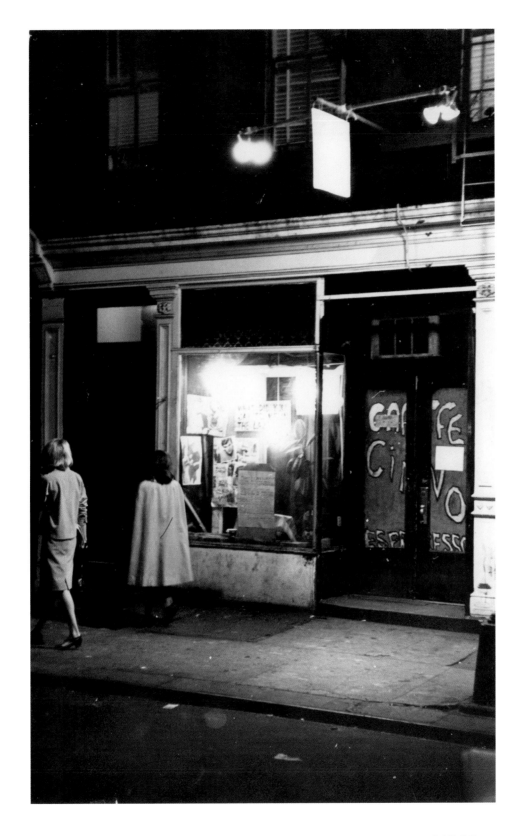

The Caffe Cino, at 31 Cornelia Street, was widely recognized as the birthplace of Off-Off-Broadway theater from 1958 to 1968. It was also highly significant as a pioneer in the development of gay theater, at a time when it was still illegal to depict homosexuality on stage.

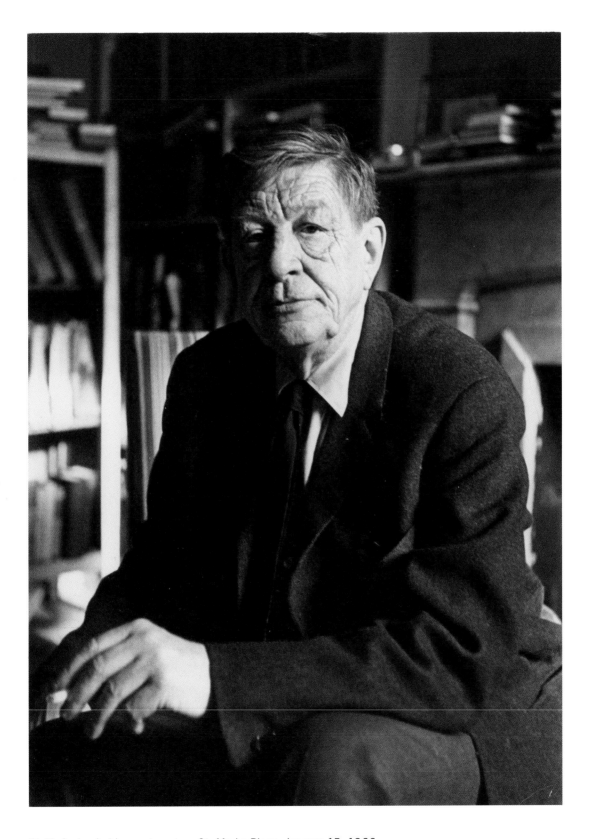

W. H. Auden in his apartment on St. Marks Place, January 15, 1966.

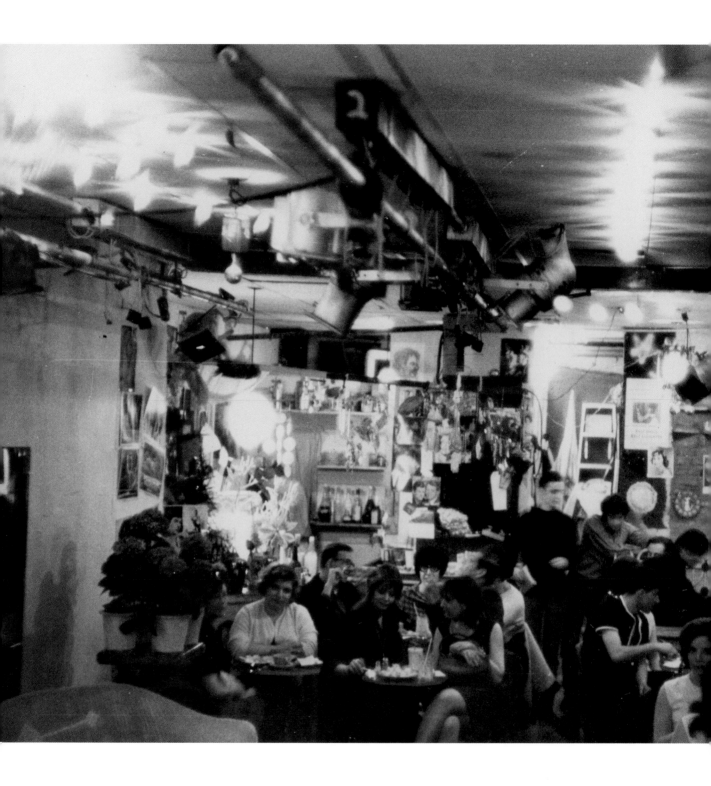

Caffe Cino interior, March 19, 1966. The coffeehouse served as a significant meeting spot for gay men. At R: Proprietor Joe Cino. His partner Jon Torrey worked as the electrician and lighting designer. It closed in 1968, a year after Cino's suicide following Torrey's accidental death.

Edie Sedgwick dancing onstage with Gerard Malanga as the Velvet Underground (Lou Reed, John Cale, Sterling Morrison, and Maureen Tucker) perform at the Film-makers' Cinematheque, 125 West 41st St., February 8, 1966.

"Rocks through windows don't open doors."
—Randy Wicker, Mattachine Society

Dick Leitsch, Craig Rodwell, and John Timmins of the Mattachine Society, an early gay advocacy group, at a Howard Johnson's at 6th Avenue and 8th Street, where they tried to order alcoholic beverages in defiance of New York State liquor laws that prohibited serving "deviants." This act of protest was called a "Sip-In": a tipsy tip of the hat to the lunch counter sit-ins then being held at restaurants that segregated black patrons. The Sip-In was a pivotal moment for the gay rights movement, predating Stonewall by more than three years.

Leitsch, Rodwell, and Timmins in front of the Ukrainian-American Village Hall, a bar on St. Marks Place, where they announced their planned "Sip-In." April 21, 1966.

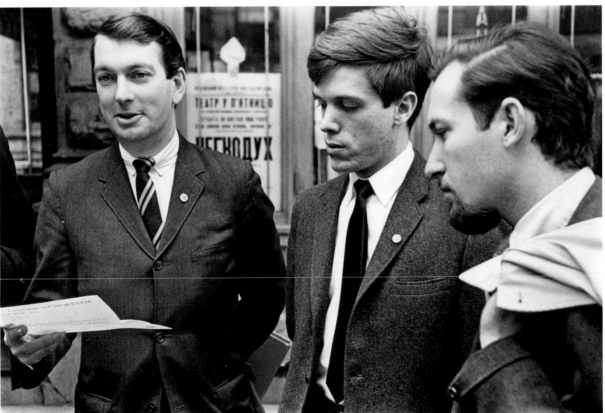

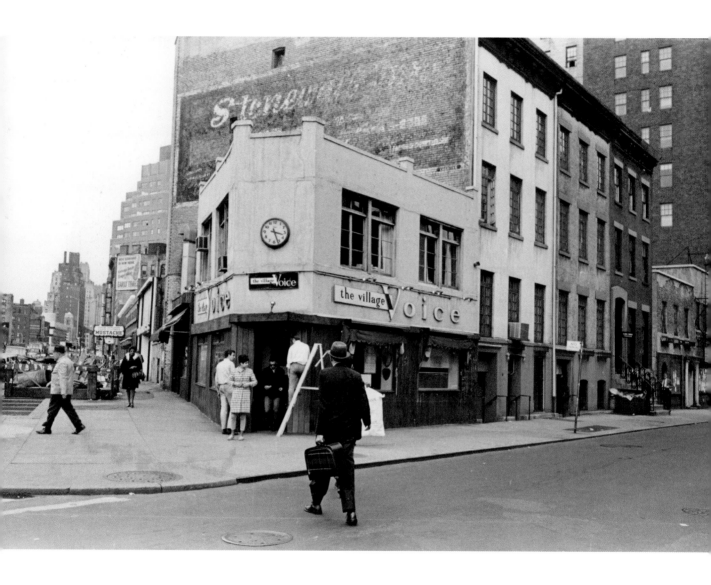

The Stonewall Inn was a quiet, little-known restaurant located near the *Village Voice* when this photo was taken on May 1, 1966; a two story building on the corner, the Duplex Cabaret, now covers the sign painted on the brick wall.

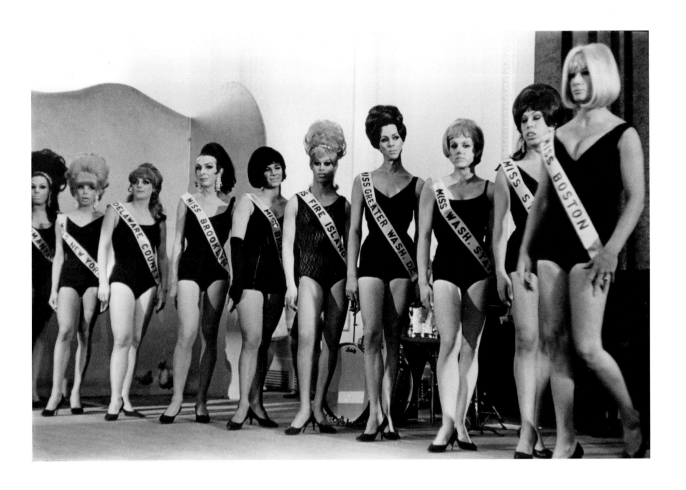

The Miss All-American Camp Beauty Pageant held at New York's Town Hall, February 20, 1967. Miss Philadelphia won first place. The judges included Terry Southern, Larry Rivers, Rona Jaffe, Jim Dine, Baby Jane Holzer, Paul Krassner, and Andy Warhol.

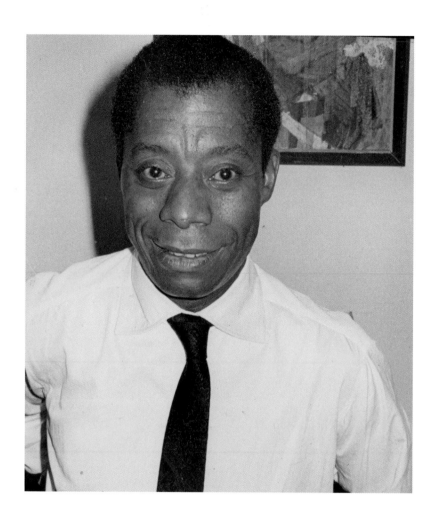

James Baldwin at the Village Theater, August 25, 1967.

"A black gay person . . . is already, long before the question of sexuality comes into it, menaced and marked because he's black or she's black. The sexual question comes after the question of color; it's simply one more aspect of the danger all black people live."

<div align="right">—James Baldwin</div>

"I came to New York in the early '60s to be a bohemian/beatnik artist. I found the Actors Studio, Lee Strasberg, Greenwich Village, jazz, mary jane, gay bars, drag queens, Andy Warhol, the Judson Church performers, the Living Theater, the Caffe Cino and La Mama, civil rights marches and sit-ins, the Open Theater, Communist, poetry, dirty old men, Lenny Bruce, rich people, and my first real boyfriend (Franklin Spodak). The decade moved fast. I went from a Max's Kansas City scenester, Hearst *Eye Magazine* columnist, and Broadway and TV actor to Hippie Leader ("Jimmy Digger"), to anti-Vietnam war protester, and underground courier for making revolution in my lifetime.

"In 1967, I came out on national television on the David Susskind Show featuring me and Abbie Hoffman. My professional acting career was pretty much killed by that one moment of truth, but it took me years to figure that out. Happenstance put me on Christopher Street as the police began to raid the Stonewall. This event changed my life forever . . . I have remained an active political person in the building of a visible lesbian and gay culture for all our kids . . . never wanting to be just like heterosexual society, hell-bent on transforming the world into a place that respects the individual, understands diversity, and defines humanity not by a series of checkoff points but by life practice . . . Love is our weapon and our strength: physical, sexual, and spiritual love. My tribe still wants: to smash patriarchy that attempts to define and limit our desire, to discover our true gay and lesbian spirit and throw off the ugly, self-loathing roles defined for us (Stonewall patrons were the epitome of the oppressed nightmare . . . without identity but united in some unconscious bond of defiance and a will to live). We are still here, hidden in the '90s marketing creation of who gays and lesbians are. . . .

"The message of that spontaneous revolutionary moment in a most tacky bar has not changed. Do not be afraid to love yourself. Hate is a straight man's tool. Don't be seduced by a straight man's weapons. Hate and greed will only perpetuate the divisions that exist within our gay and lesbian society as it does to divide women and men, different colors of people, and rich and poor in the dominant society.

"Be positive and build a brave new world. And never, ever let anyone tell you not to have fun."

—Jim Fouratt

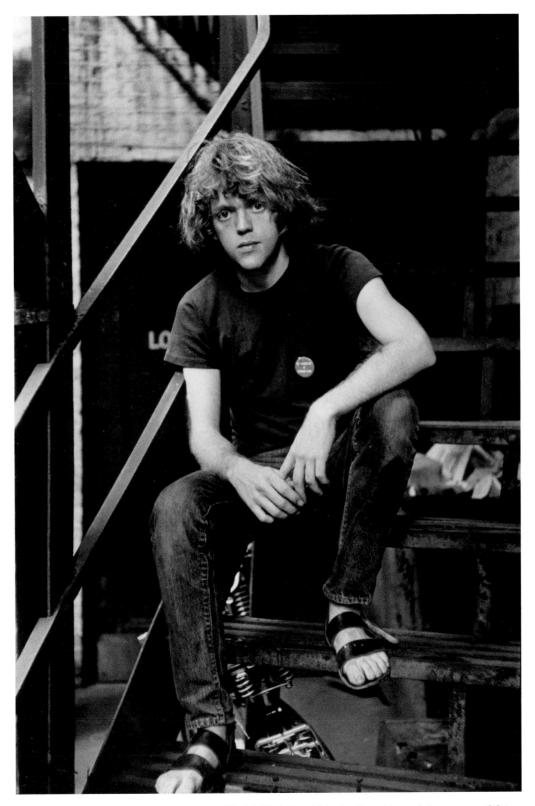

Jim Fouratt on St. Marks Place, October 16, 1967. A street hippie, Fourett was later a gay activist and organizer of the Gay Liberation Front as well as the Gay Activists Alliance.

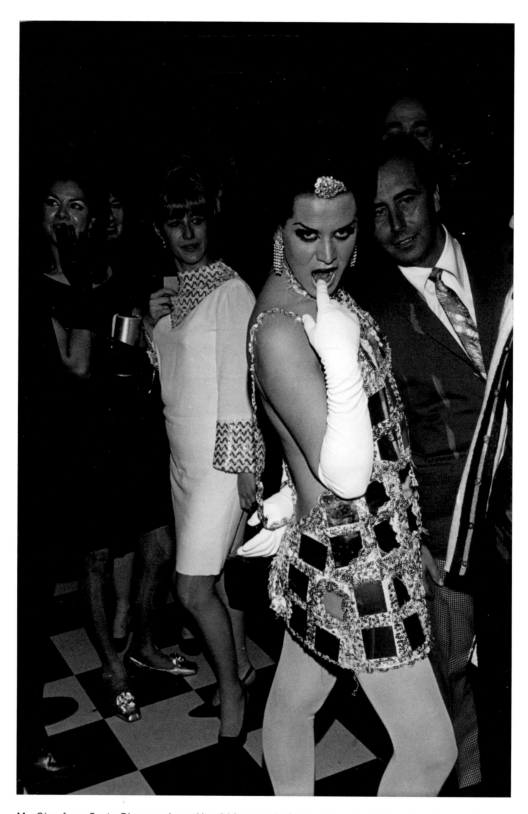

Mr. Gina from Costa Rica wearing a Henri Lissaver designer dress at a Mattachine Society Ball, October 27, 1967, held at the famous, very seedy Hotel Diplomat on West 44th Street.

Novelist and essayist Edmund White distinctly remembers a bar he used to frequent, pre-Stonewall, called the Blue Bunny. "It was a typical joint with a bar in the front, which was sort of innocuous. Then there was a wrought-iron grille. Behind that grille there was a dance floor. And on the grille there were Christmas tree lights that would be turned on by the bartender whenever a suspicious plainclothesman would come in. When that happened, we would all instantly break apart and stop dancing."

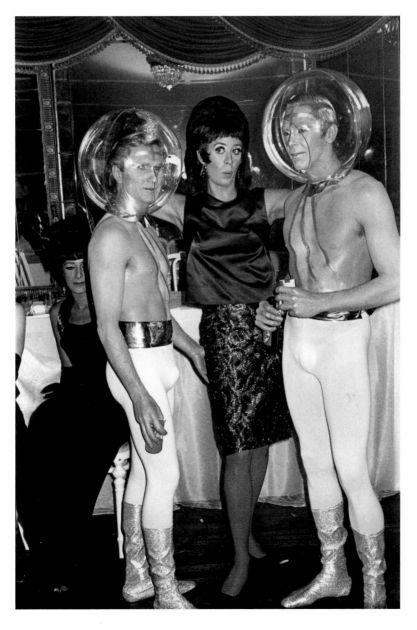

Spacemen, Mattachine Society Ball, October 27, 1967.

British fashion photographer Cecil Beaton (L) talks with Andy Warhol and twin brothers Jed and Jay Johnson at the Factory (then on the sixth floor of the Decker Building at 33 Union Square West, near the corner of East 16th Street) April 24, 1969. Initially hired by Warhol to sweep floors at the Factory, Jed Johnson subsequently moved in with Warhol and for twelve years was his lover.

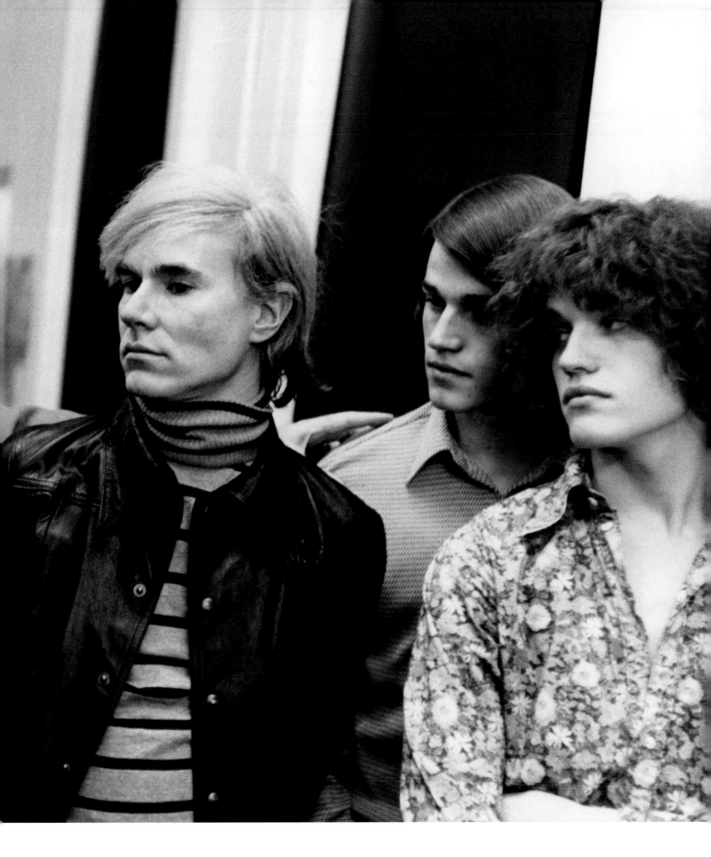

PHOTOGRAPHS

AFTER STONEWALL

After World War II, many gay people settled in Greenwich Village. Traditionally an artistic community, the Village offered gays an opportunity to form supportive social networks. They frequented the saloons along MacDougal Street, went to the beaches at Cherry Grove and Riis Park, and pretty much kept to themselves. Still, they were always at risk of being found out at their jobs or by their families. Early on, these social networks began taking political form and, by the late '50s, the Mattachine Society and the Daughters of Bilitis encouraged gays and lesbians to deal with the prejudice against homosexuals. Taking a cue from the antiwar, civil rights, and feminist movements, gays demanded equal rights. They did not want to be harassed any more; they wanted to be heard and respected. The single incident that marked the birth of the modern gay and lesbian movement was the Stonewall Inn rebellion on the weekend of June 27, 1969.

The Stonewall Inn at 53 Christopher Street was a speakeasy during prohibition, later a restaurant catering to weddings and banquets, and then a gay bar. Saloons serving homosexuals were denied liquor licenses in those years, and it was illegal for gays to gather anywhere. Gay bars paid off the police to stay open, but many were harassed anyway because they operated without licenses; police could close them down at will. The Stonewall's kickbacks to the local cops and their Mafia vendors was reported to be $2,000 a week, but the bar took in nearly $12,000 every weekend.

The raid on the Stonewall was made by two cops, two undercover agents, and two policewomen who went inside to "observe the illegal sale of alcohol." Once inside, the detectives called the Sixth Precinct on a pay phone for backup, and the arrival of the additional cops set off the incident. Patrons were herded out of the bar while cops, headed by Deputy Inspector Seymour Pine, were pelted by gays throwing everything they could find. Thirteen people were arrested.

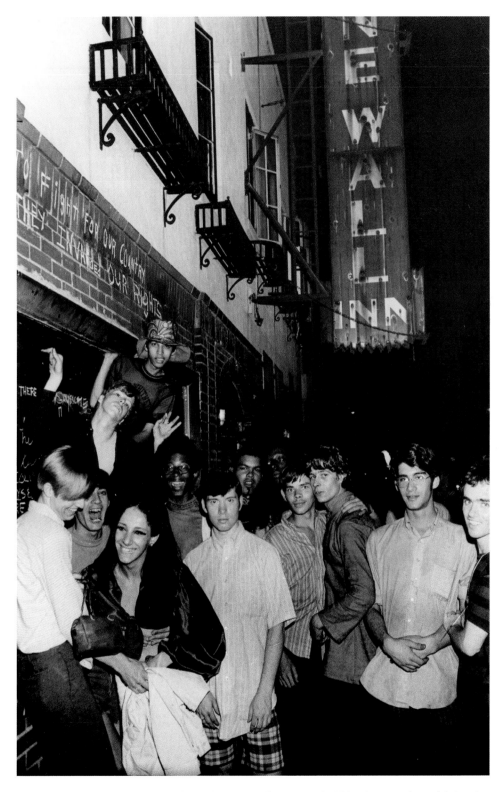

The Stonewall riots started on Friday night, June 27, and ended Monday morning, with breaks in between for a victory celebration. The chalked message on the wall says, "To fight for our country, they invaded our rights."

In the course of the raid, all the mirrors, jukeboxes, phones, toilets, and cigarette machines were smashed. Even the sinks were stuffed and overflowing.

The *Village Voice* was the only New York paper to cover the event, with Howard Smith writing from the inside and Lucian Truscott IV reporting from the outside; Truscott wrote that "Sheridan Square this weekend looked like something from a William Burroughs novel as the sudden specter of 'Gay Power' erected its brazen head and spat out a fairy tale the likes of which the area has never seen."

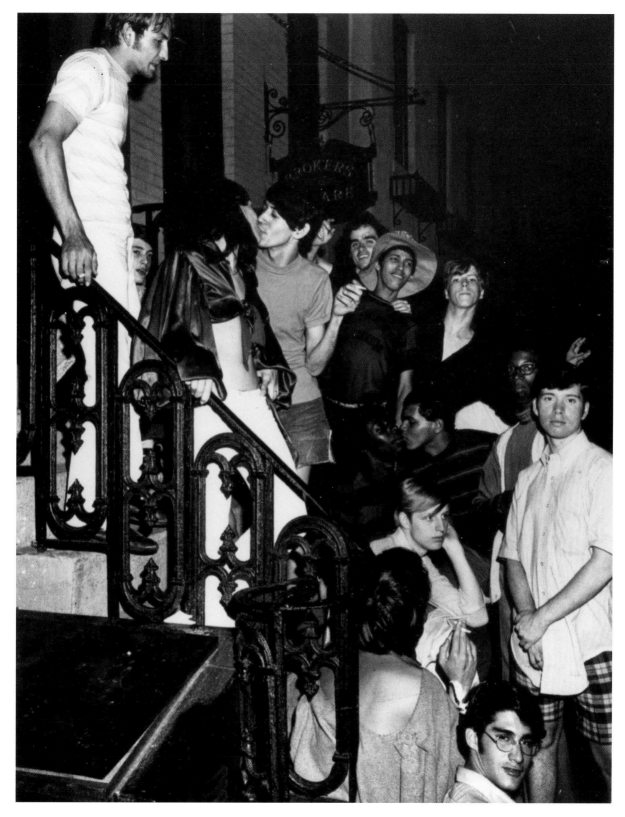

June 27, 1969.

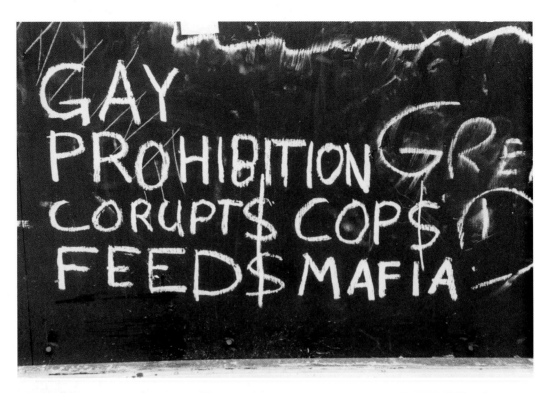

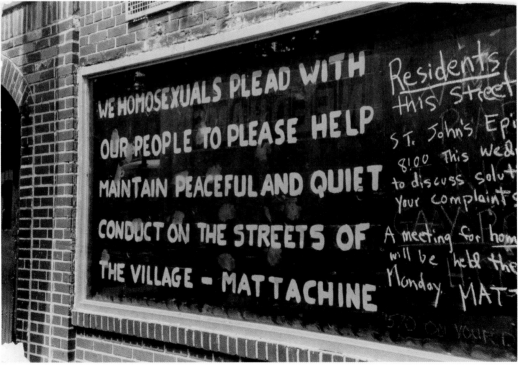

The windows of the Stonewall were boarded up with plywood and painted black after the riots. Members of the Mattachine Society as well as irate customers covered the windows with graffiti. The top statement refers to the fact that cops took payoffs from members of the mob who operated the illegal gay bars. Photographs taken over the weekend of June 27, 1969.

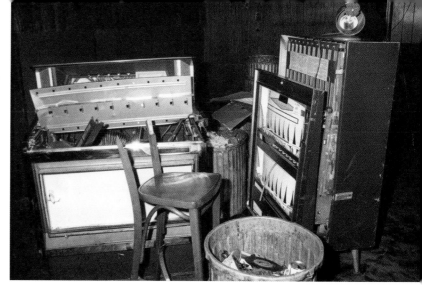

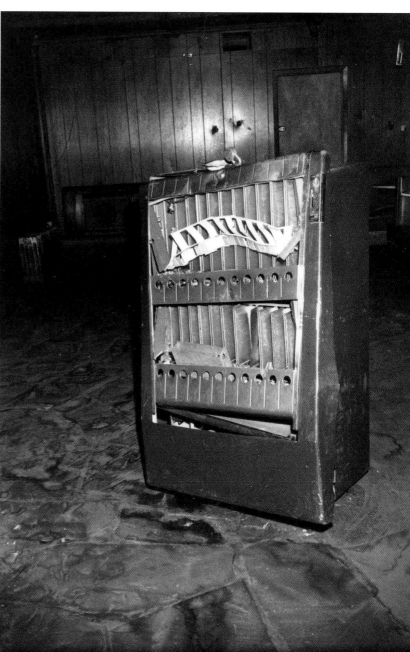

Inside the Stonewall Inn after the riots,
the weekend of June 27, 1969.

1969 March

Exactly one month after Stonewall on July 27, 1969, the Mattachine Society and the Daughters of Bilitis organized the first mass rally for gay rights. Starting in Washington Square Park, fewer than two hundred openly gay men and lesbians assembled. The rally started with the distribution of lavender ribbons and armbands that apparently many were reluctant to wear. Martha Shelley, from the Daughters of Bilitis, an experienced antiwar protester at the Democratic National Convention in 1968, stood on the fountain rim and greeted her brothers and sisters, as reported in the *Village Voice*; "We're tired of being harassed and persecuted. If a straight couple can hold hands in Washington Square [Park], why can't we?. . . We're tired of straight people who are hung up on sex; tired of flashlights and Peeping Tom vigilantes; tired of marriage laws which punish you for lifting your head off the pillow. Socrates was a homosexual; Michelangelo was homosexual; Walt Whitman and Richard the Lion-Hearted were homosexuals."

Marty Robinson from the Mattachine Society continued with "Let me tell you homosexuals, we've got to get organized; we've got to stand up." He then led the protest march to Sheridan Square Park, where residents along West 4th Street gaped in astonishment. Nothing like this had ever been done before. Gay power, with banners waving and fists flying, had surfaced. This was only the beginning.

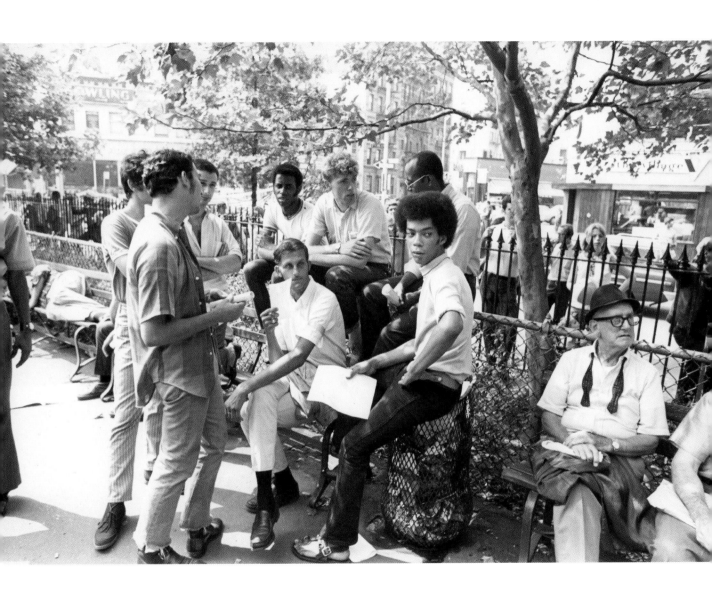

Christopher Park, July 27, 1969.

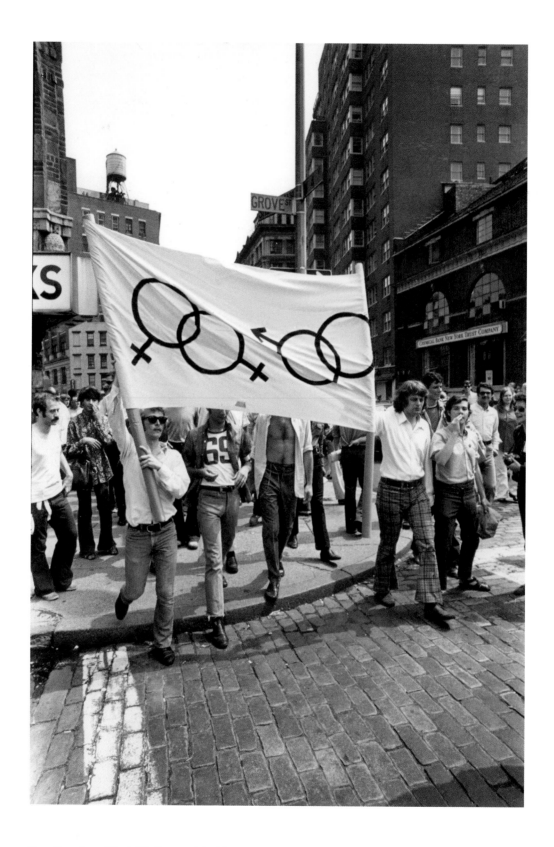

Parading down West 4th Street, July 27, 1969.

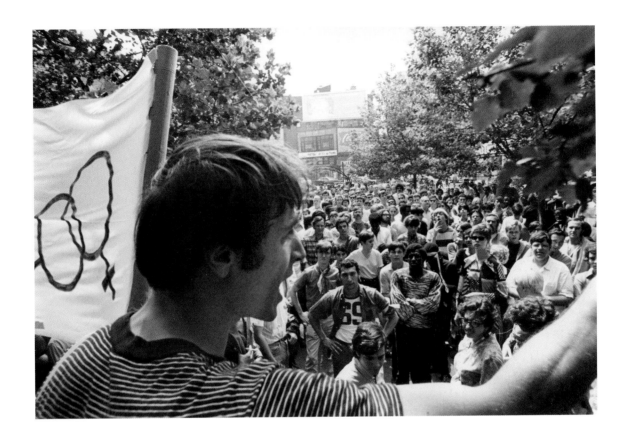

Marty Robinson told the assembled crowd that, "Gay power is here . . . There are one million homosexuals in New York . . . we will not permit another reign of terror." July 27, 1969.

"I was there [at Stonewall]—I walked by earlier in the day before anything had happened. I didn't even know it was a gay bar. I was closeted at the time. No one new at the time that it was a watershed event. I got involved some months later when a bar called The Snake Pit got raided in February 1970. There were 187 people arrested and an Argentinian named Diego Viñales jumped from the police precinct window and was impaled by a fence below.

"I was the vice president of a group called the Gay Activists Alliance. There was also the Gay Liberation Front. Those groups pretty closely parallel Act-Up and Queer Nation. I think that after the quiet of the late '70s things picked up again in the early 1980s in large part because of AIDS.

"The real issue is that we've made ourselves visible and real. That was the first challenge. When we first appeared as a minority group it wasn't legitimate. Color or ethnicity was valid, but sex didn't count."

—Arnie Kantrowitz, professor, College of Staten Island

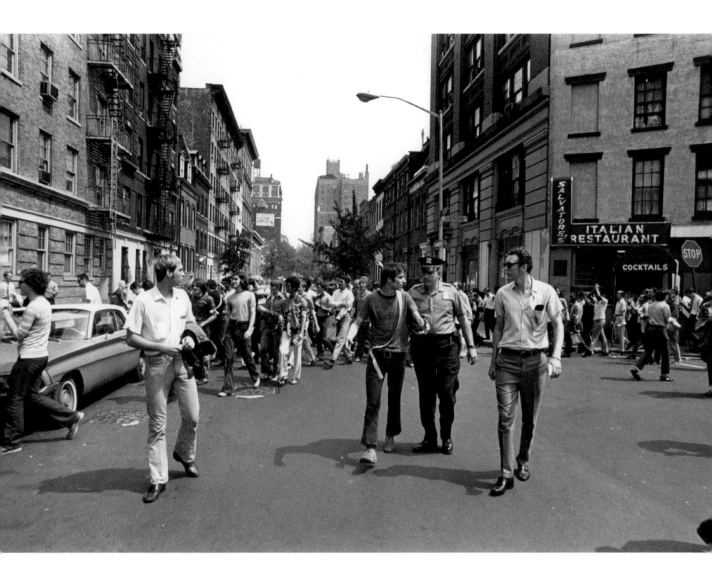

In contrast to the Stonewall riots a month earlier, only one patrolman was assigned to this march: he is shown here warning Marty Robinson not to incite the crowd. July 27, 1969.

Dick Leitsch, August 21, 1969.

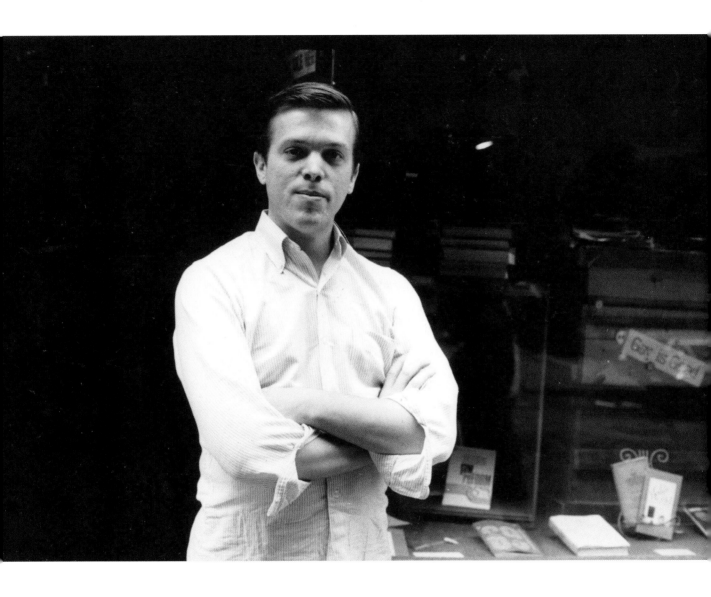

Craig Rodwell, October 14, 1969, at the Oscar Wilde Memorial Bookshop, then located at 291 Mercer Street. It was one of the nation's leading stores for serious literature on gay and lesbian issues.

Carlin Jeffrey performing on April 4, 1970 at a private party in an after-hours club. He became a living sculpture on a cross as a tribute to the gay people who died in American wars.

1970 March

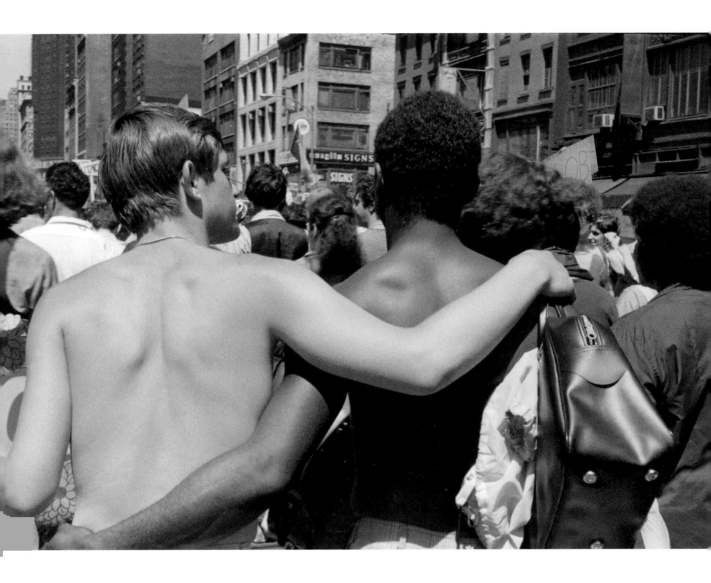

Walking arm in arm. June 28, 1970.

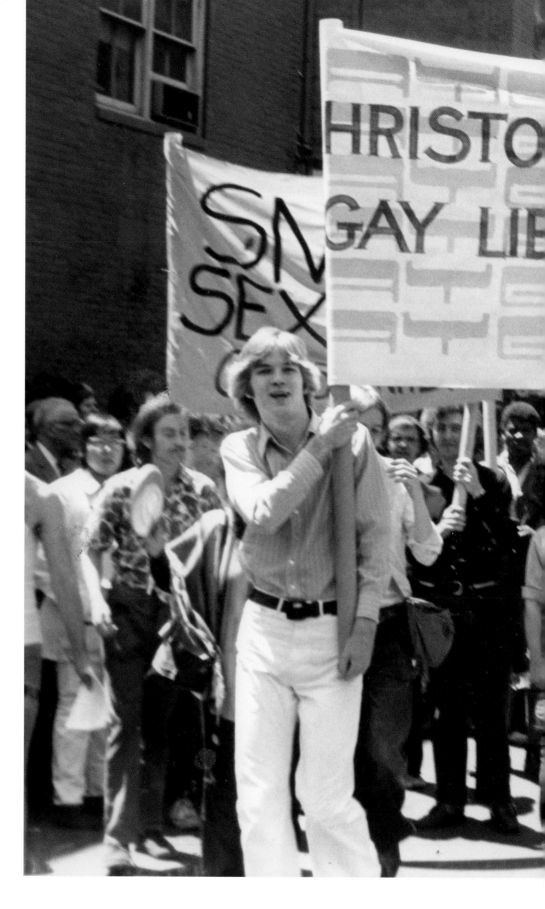

The first Stonewall anniversary march, held on June 28, 1970, was organized by the Christopher Street Liberation Day Committee, led by Foster Gunnison and Craig Rodwell.

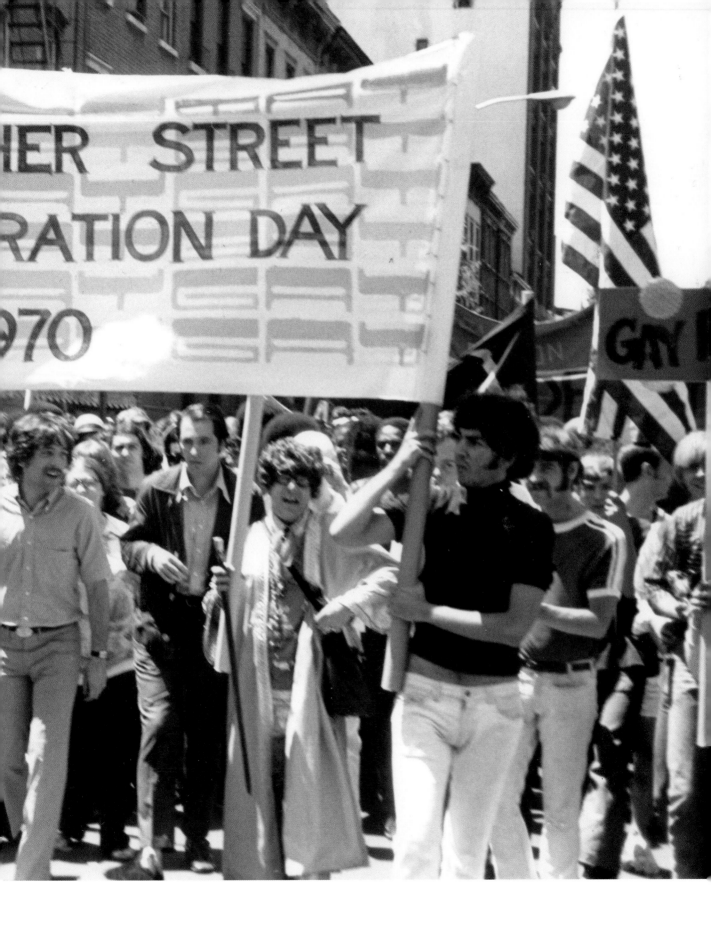

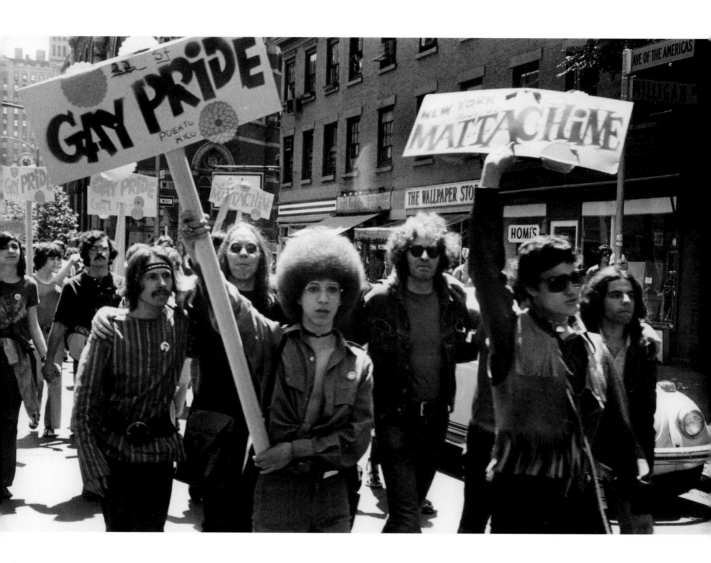

June 28, 1970.

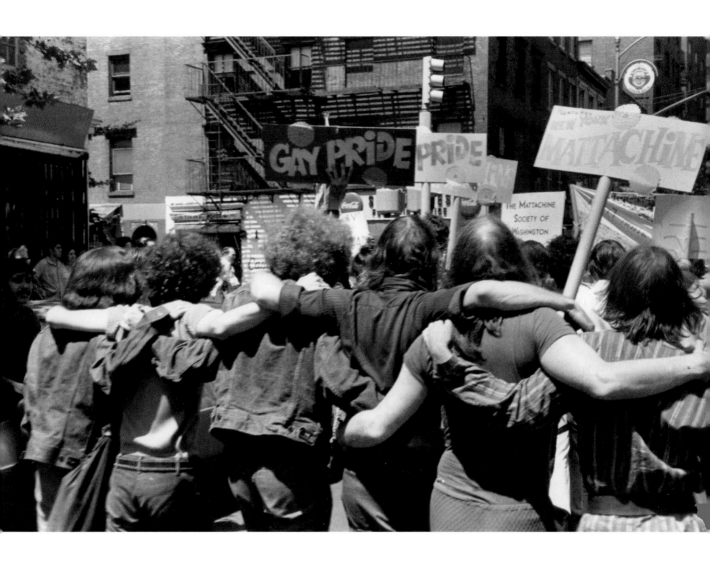

June 28, 1970.

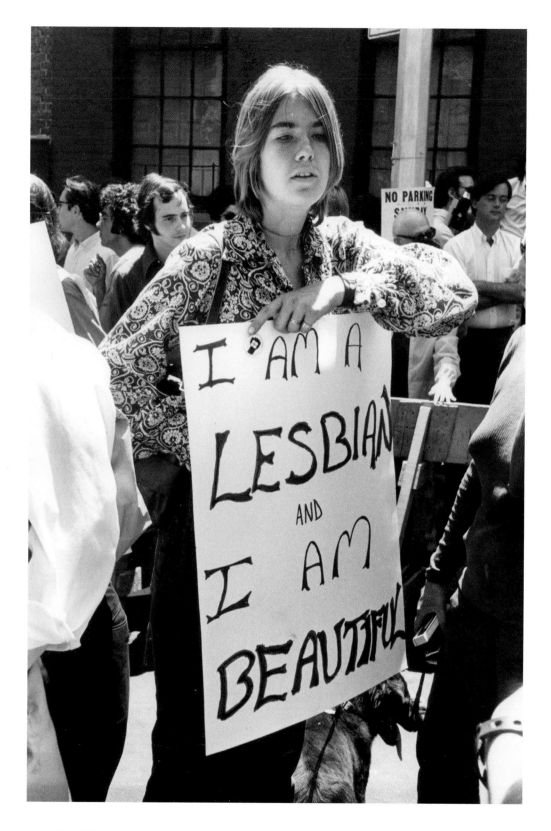

June 28, 1970.

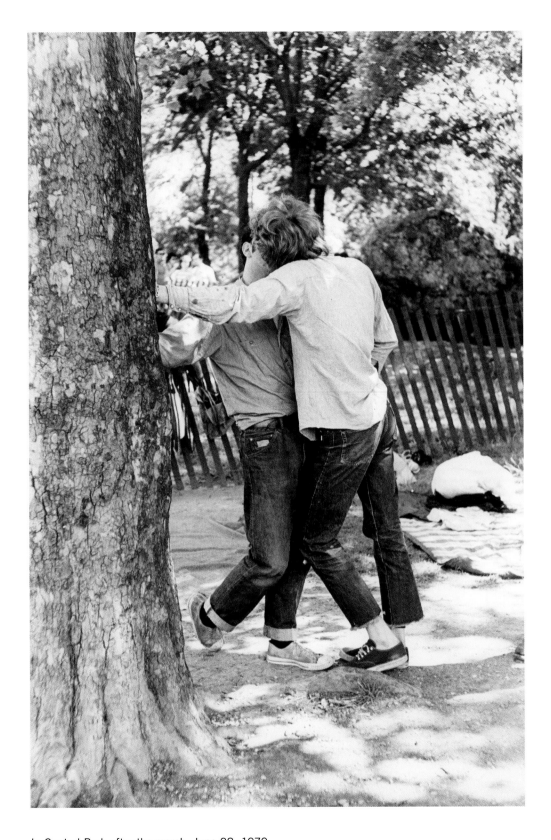

In Central Park after the march, June 28, 1970.

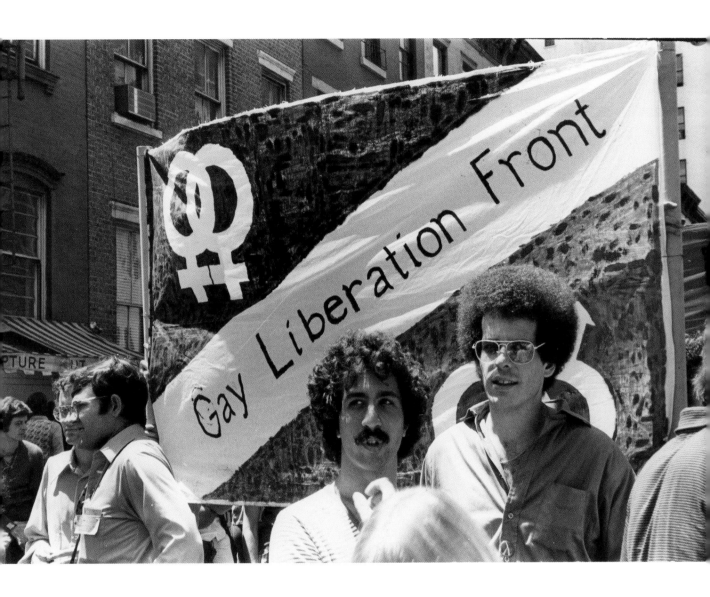

The Gay Liberation Front, June 28, 1970.

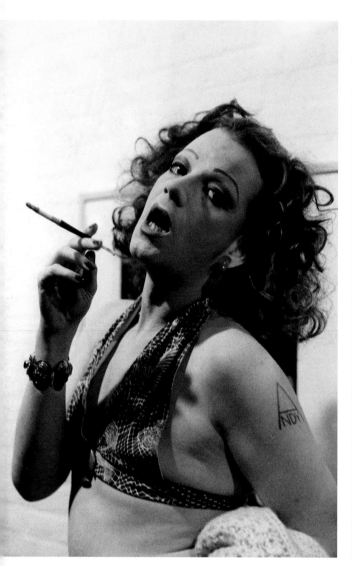

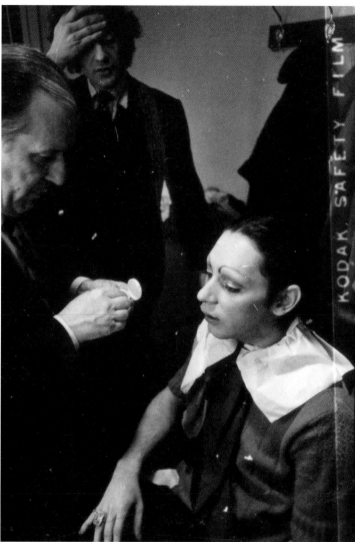

Actor, writer, and Warhol Superstar Jackie Curtis at a book party for Guy Peellaert's *Rock Dreams* in New York. December 3, 1974.

Warhol Superstar Holly Woodlawn putting on makeup for an appearance on the *David Susskind* show, December 7, 1970. "I had my own gang to run with except that we were a bunch of mad queens who invaded the Stonewall every night and had a ball," she wrote in her memoir, *A Low Life in High Heels.*

Warhol Superstar Candy Darling, who starred in Warhol's films *Women in Revolt* and *Flesh*, December 7, 1970.

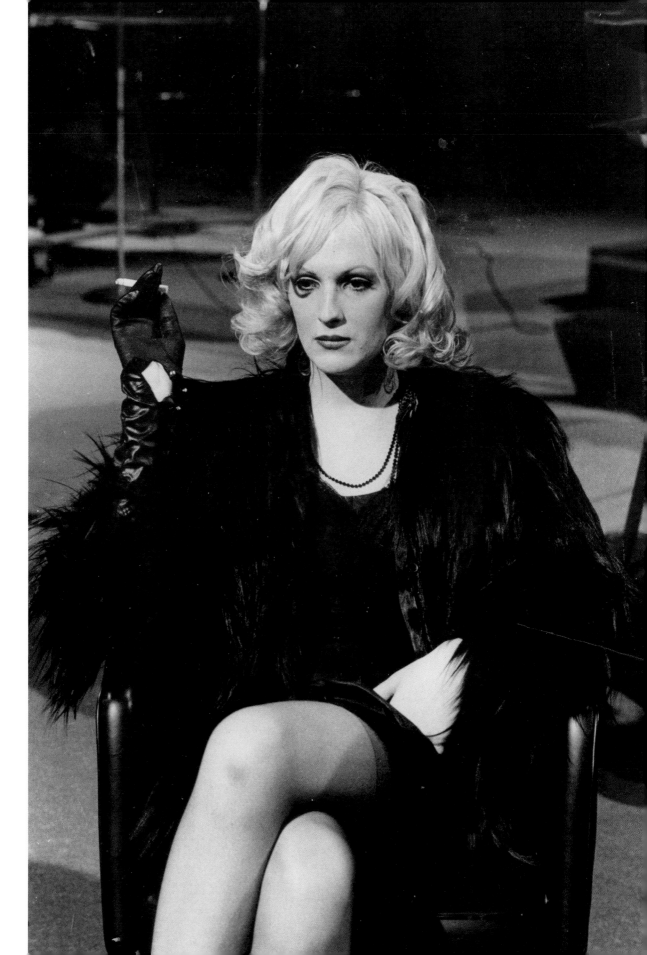

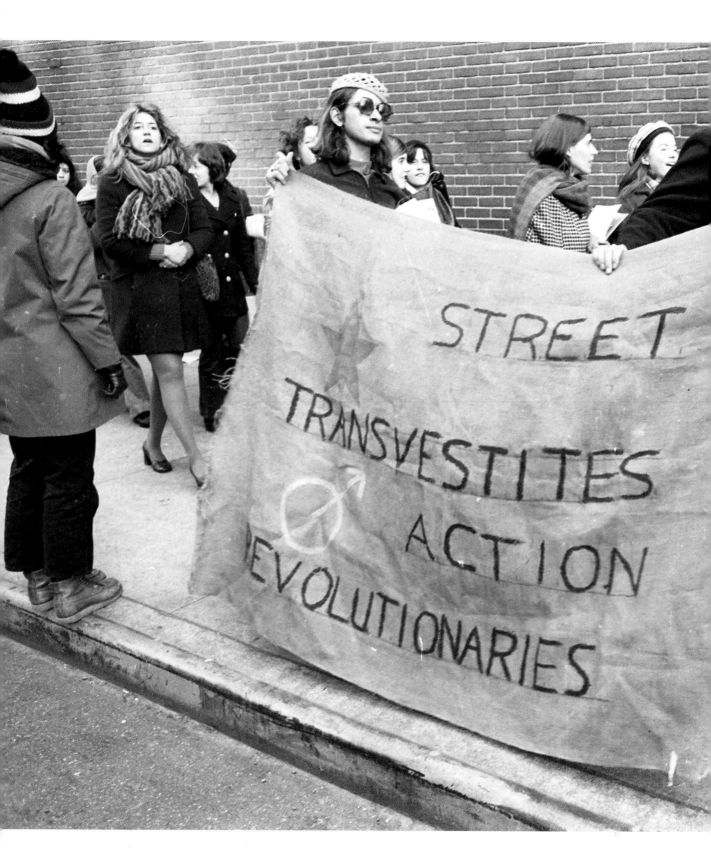

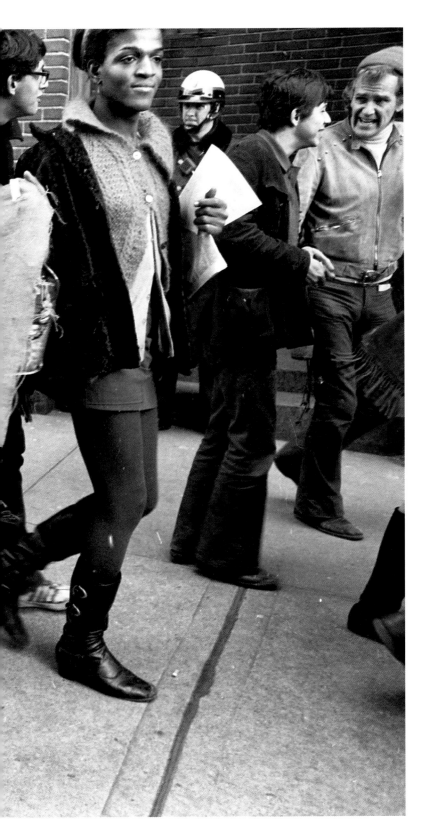

A protest by the radical, intersectional activist collective STAR (Street Transvestite Action Revolutionaries) passes in front of the Women's House of Detention, Greenwich Avenue near Christopher Street, December 19, 1970. The banner is carried by Sylvia Rivera (L, in knit hat) and Marsha P. Johnson (R, in cardigan and skirt). Rivera and Johnson, both trans women of color, were outspoken gay rights advocates, and were prominent figures in the Stonewall uprising. They co-founded STAR, which focused on providing housing and support to homeless gay youth and sex workers.

Years before the converted school on West 13th Street became the Lesbian and Gay Center, another abandoned building public space was the vortex of gay life. A four-story building at 99 Wooster Street that was at one time a city firehouse was leased by the Gay Activists Alliance. Every Thursday evening there were general meetings, and Saturday nights brought "Liberation Dances," a cross "between Woodstock and Dante's *Inferno*," as one patron described it.

The main dance took place on the ground floor, where the general meeting space was converted into a dance hall by removing all the chairs. The basement had cans of beer in iced garbage cans. The second floor had bridge tables and a coffee nook. The third floor had a small theater and the top floor housed offices.

The GAA, according to one of its founders, Arthur Bell, was set up as an activist organization, but broadened its scope to include social and sociological aspects of gay life, which is why it opened the Firehouse. The Mattachine Society was far more conservative and thought of primarily as a "service" organization that did not conduct outside activities or run clubhouses. There were also fringe groups, like STAR (Street Transvestite Action Revolutionaries) and the Gay Revolution Party, both of which were for overthrowing and disrupting the government and other gay organizations.

The Firehouse building was bombed and burned down on October 15, 1974, and the social club never reopened.

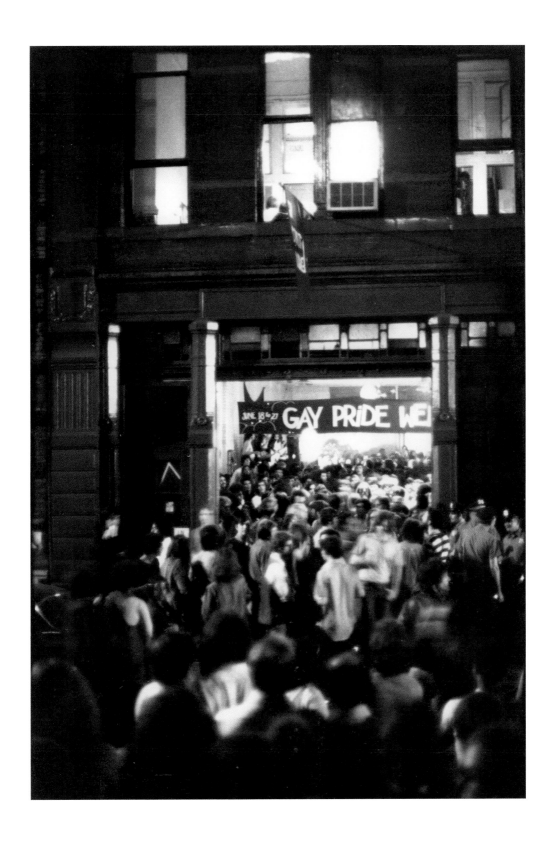

The kickoff event of 1971's Gay Pride Parade, June 11, 1971.

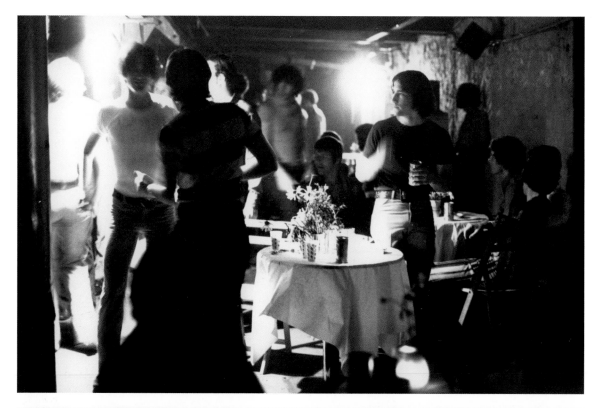

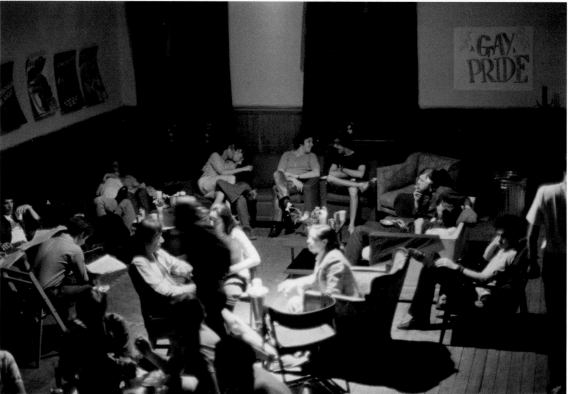

Inside the Firehouse, June 11, 1971.

"Like racism, homophobia is in the air we breathe. 'Fag' jokes, 'lezzie' allusions, hand signals—like the pinky wetted and then moved over the eyebrow—were part of the cultural fabric of the 1950s. Limp wrists or square shoulders, a hip thrown out or a short haircut became code images for biological freaks, for people who confused others because they crossed into territory reserved for the opposite gender. How desperate people were, and are, to defend that gender territory, perhaps the only territory some have left that they can still control."

—Joan Nestle, cofounder, Lesbian Herstory Archives

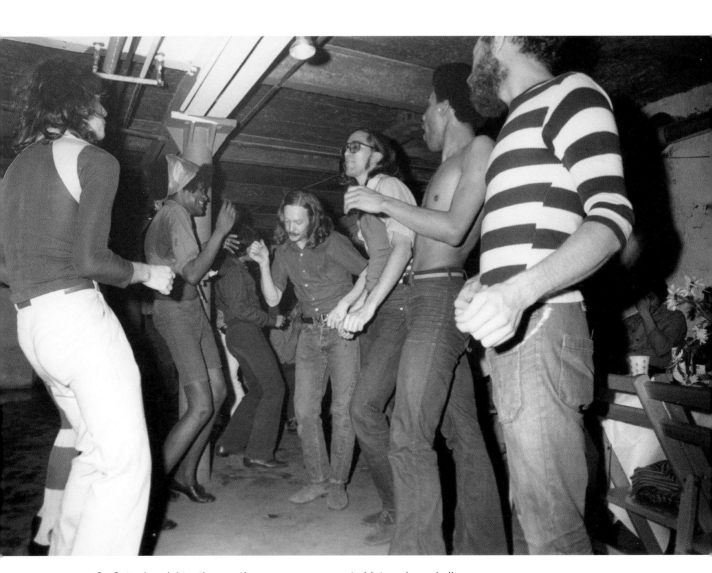

On Saturday nights, the meeting space was converted into a dance hall.

1971 March

"The diagnosis of homosexuality as a 'disorder' is a contributing factor to the pathology of those homosexuals who do become mentally ill. . . . Nothing is more likely to make you sick than being constantly told you are."
 —Ron Gold, National Gay and Lesbian Task Force

Stirring up support for the march, June 21, 1971.

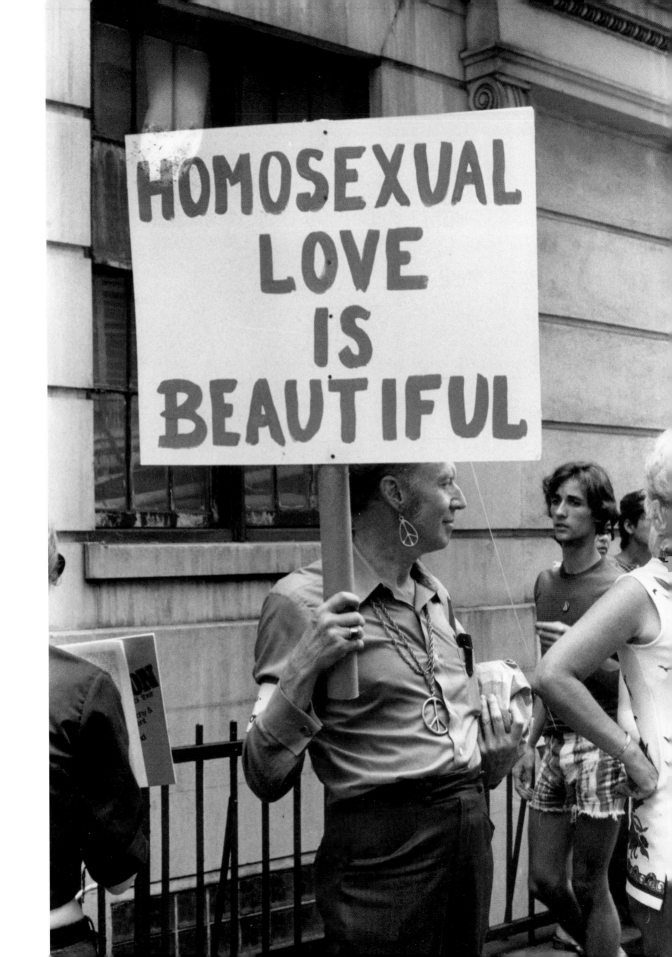

Kate Millett, pioneering feminist writer and activist, at the Gay Pride March, June 27, 1971.

"The gay rights movement had all the more to fight back against—homophobia, racism, sexism—since it incorporated problems encountered by other, often parallel movements, like civil rights or the women's movement. Gays and lesbians have had to struggle against, among other things, ethnic, religious, sexual, and racial prejudice."

<div align="right">—Kate Millett</div>

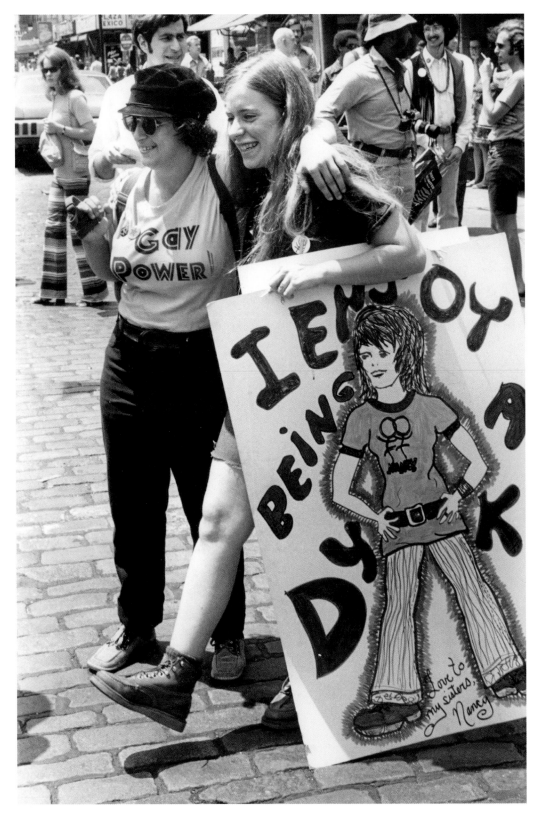

June 27, 1971.

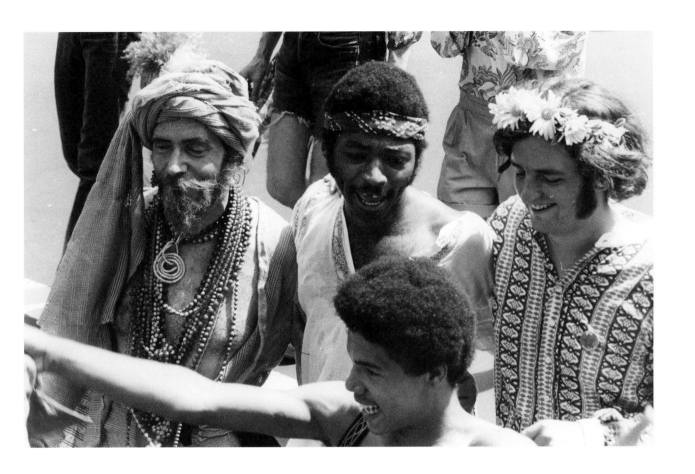

June 27, 1971.

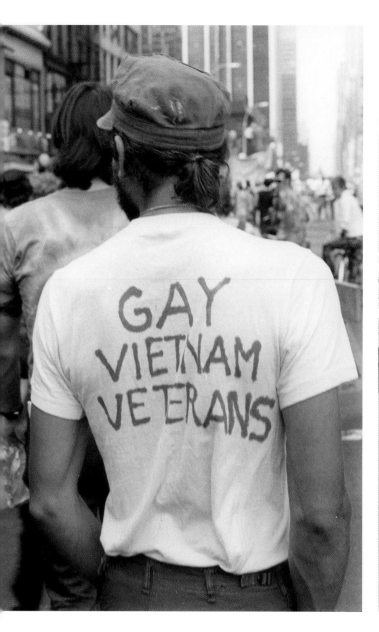

June 27, 1971.

June 27, 1971.

Trans activist and STAR co-founder Marsha P. Johnson (R) and unidentified friend, June 27, 1971.
A popular figure in New York's downtown art scene, Johnson modeled for Andy Warhol.

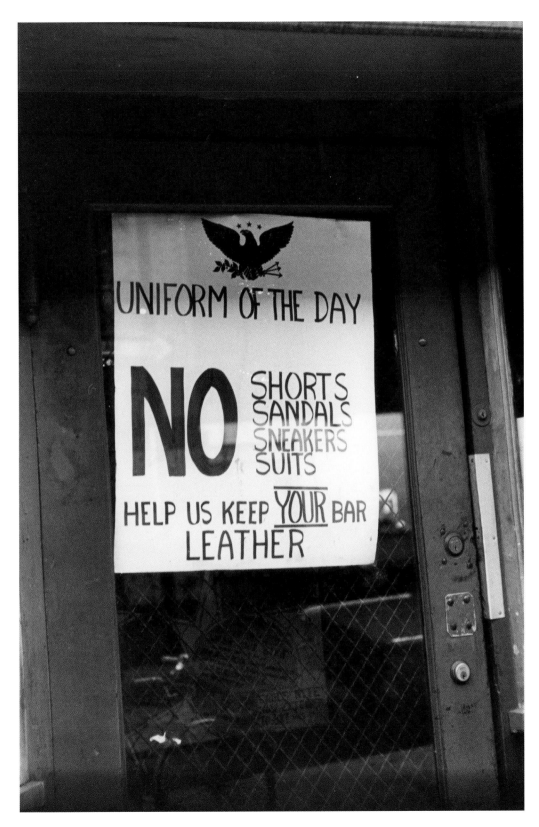

The Eagle Tavern on the waterfront, August 31, 1971.

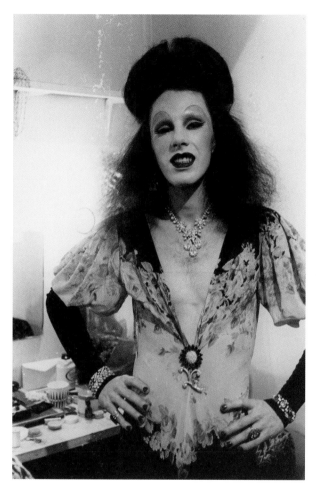 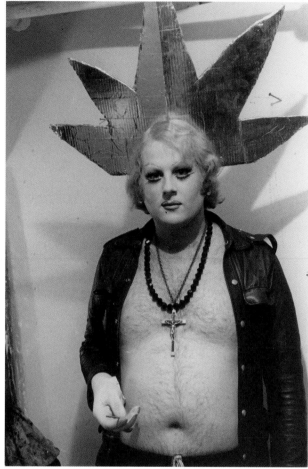

Avant-garde performance troupe The Cockettes, photographed on October 30, 1971 during their New York production of *Tinsel Tarts in a Hot Coma,* a satire of 1930s musicial comedies.

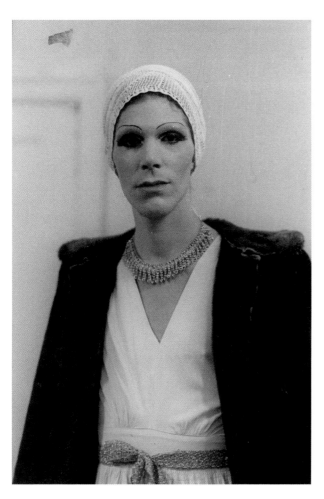
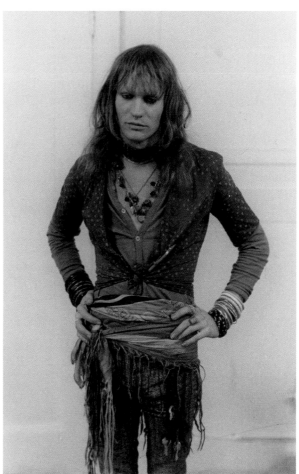

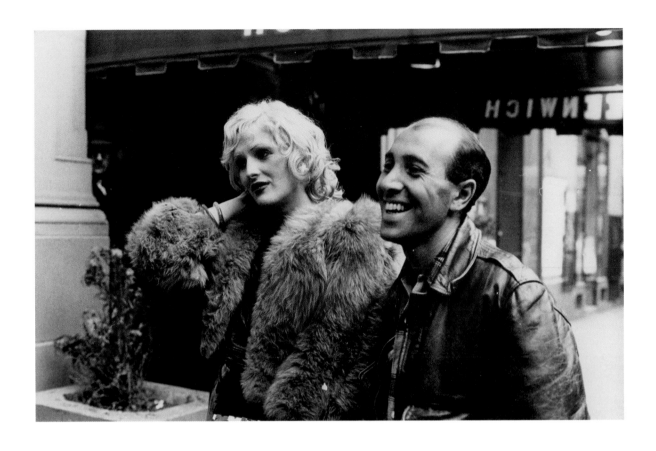

Candy Darling and playwright Tom Eyen, May 8, 1972, heading into the OBIE Awards at the Village Gate, 152 Bleecker Street. Candy played the lead in Eyen's *Give My Regards to Off-Off Broadway.*

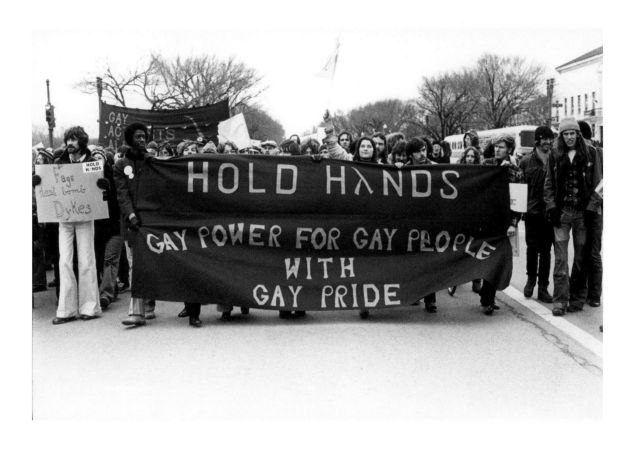

January 20, 1973. The antiwar march on Constitution Avenue during Nixon's inauguration included gay rights protesters.

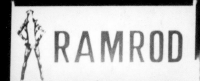

"Pre-AIDS, at places like the Anvil and the Mineshaft, there was blatant, open sex, everywhere you turned. I'll never forget walking into the Mineshaft with a friend of mine from Florida. There was this man lying in a tub getting pissed on—it's called golden showers. My friend was closeted at the time and had never seen anything like New York's sex clubs. You'd walk through these places and you'd get groped and fondled. There were guys in stirrups waiting to get anally fucked by anyone who'd come over. I used to represent a place called the Comeback Club, and one night a week there was a party called the Pubic Hair Club for Men. It was wild. But those days are virtually gone. Ever since the AIDS epidemic, while there are still sex clubs in town, most don't have the blatant stuff. The clubs that are here are packed to the gills, but there is condom distribution and a real awareness on everyone's part of the dangers of unprotected sex. Of course there are always a few renegades—people and clubs—and boy are they stupid. They're committing suicide."

—Bruce Lynn, club promoter

.

"Nightlife is the most superficial element of the gay community. It has always been a source of positive energy and a lot has happened with it, but a lot of people think clubs and bars are the be-all and end-all of being gay. That just isn't the case. Trends, fashions, and styles began in the gay clubs. AIDS obviously cast a somber tone on everything and really threw people for a loop. It almost ended nightlife. But it also brought a few people in the gay community closer and now it is stronger than ever—with nightlife playing little part in that. It was a terrible price, but as a result the gay community has risen up to greater heights than ever."

—Michael Musto, former columnist for the *Village Voice*

The Ramrod: the most popular waterfront bar on West Street. March 2, 1973.

1973 March

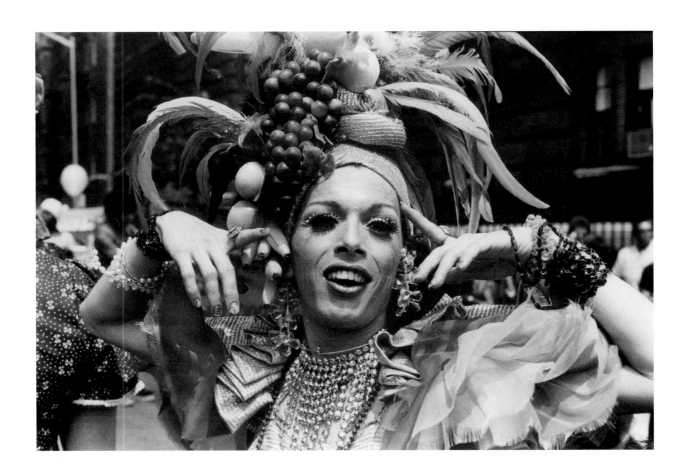

June 24, 1973.

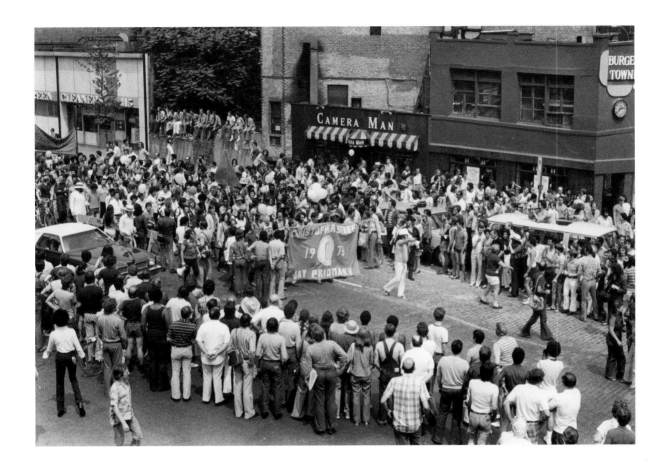

"We have got to get gay people now to do what blacks did in the '60s. Until they come out and get into political actions, we are in trouble."

—Bayard Rustin, civil rights leader

June 24, 1973.

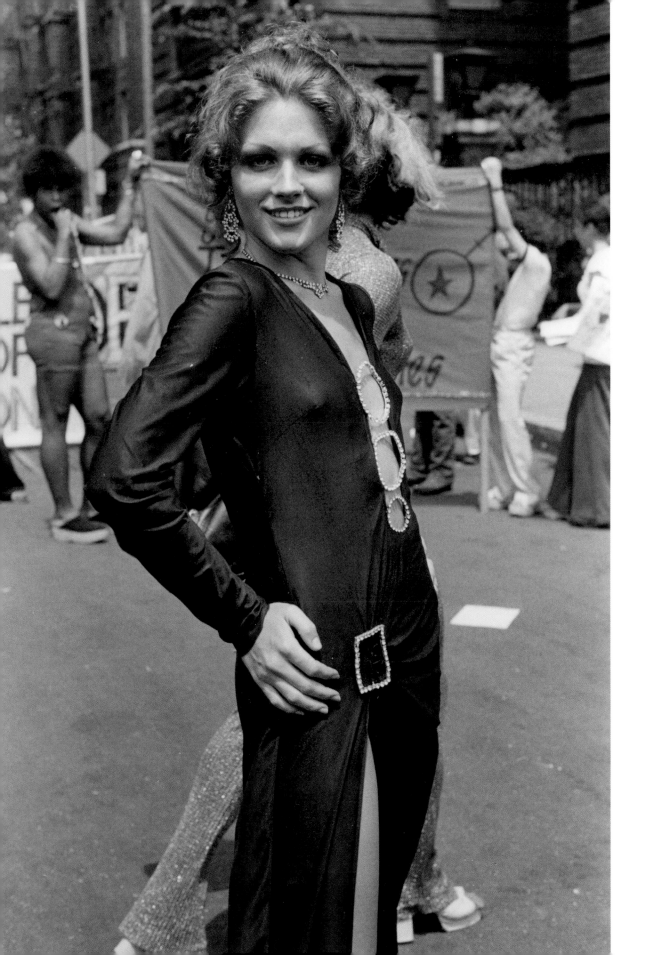

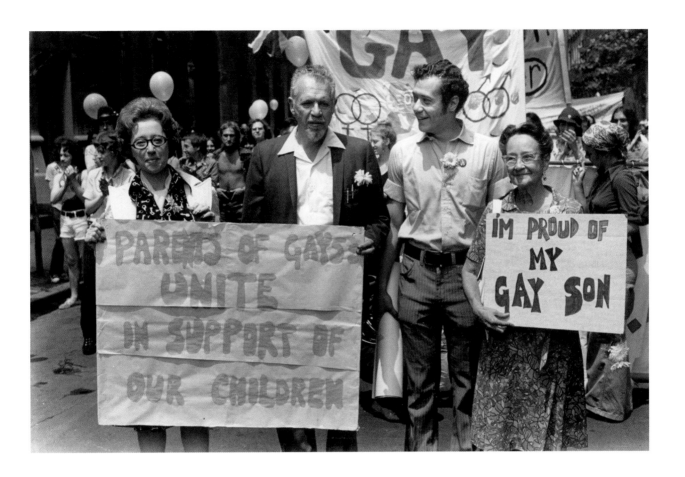

Jeanne and Jules Manford march with their son Morty, along with Sarah Montgomery, June 24, 1973. According to public relations executive Ethan Geto, a year earlier Morty was beaten at an annual dinner for New York press by the fireman's union chief because he was handing out pro-gay leaflets.

June 24, 1973.

"I'd like to see us help gay men become more feminist. The gay women have been incredible with the AIDS crisis, and they have really come forward and contributed in any way they can. Now it's appropriate for gay men, since they have accepted our help and love and work, to work on women's issues."

—Rita Mae Brown, novelist

Dr. Larry Rosen of the BDSM education and support group The Eulenspiegel Society, June 24, 1973.

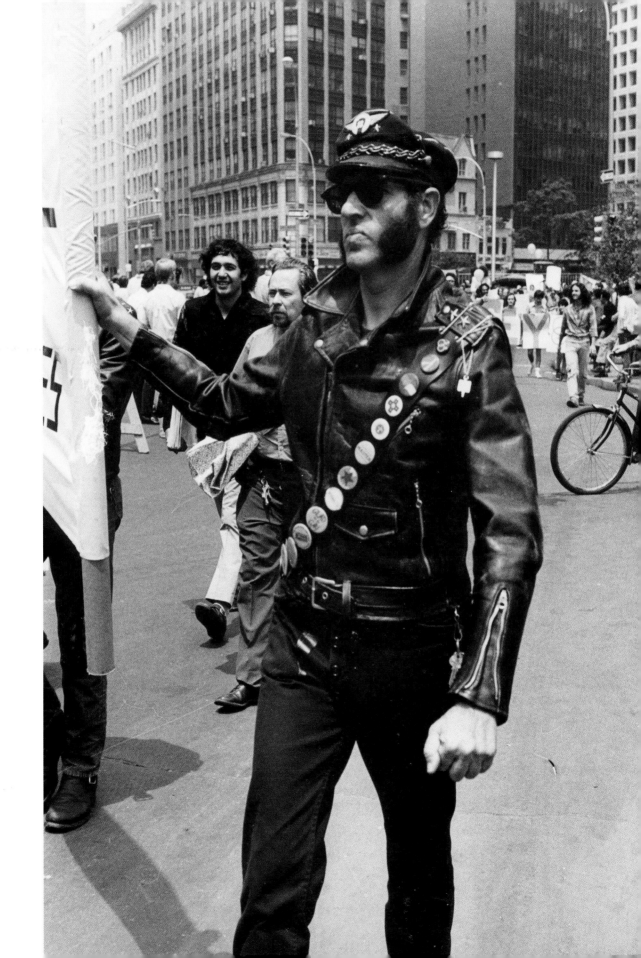

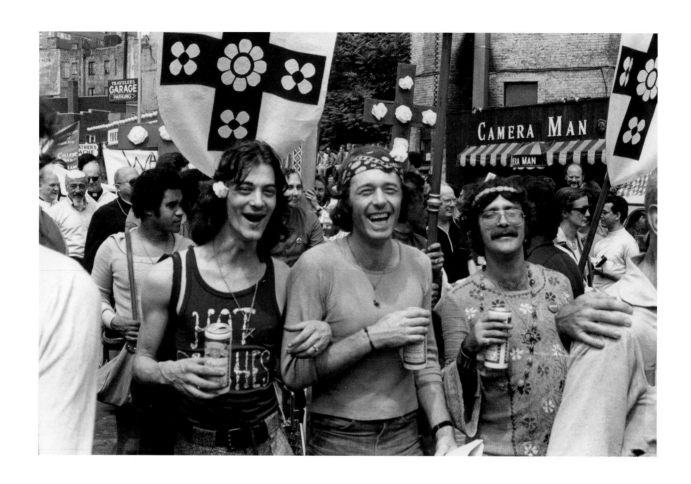

June 24, 1973.

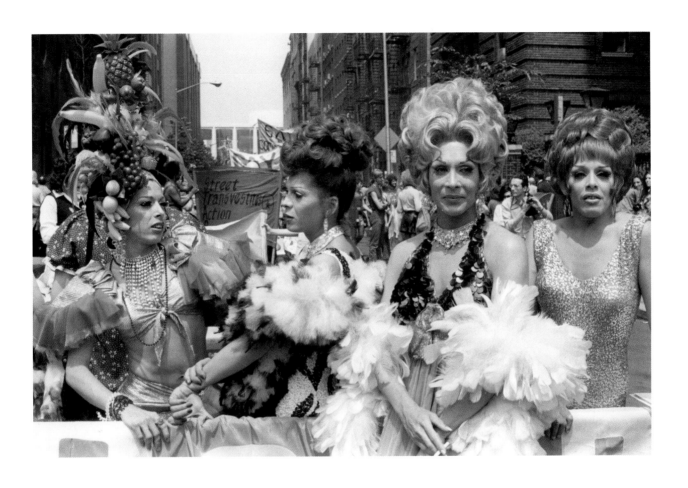

STAR (Street Transvestite Action Revolutionaries), June 24, 1973.

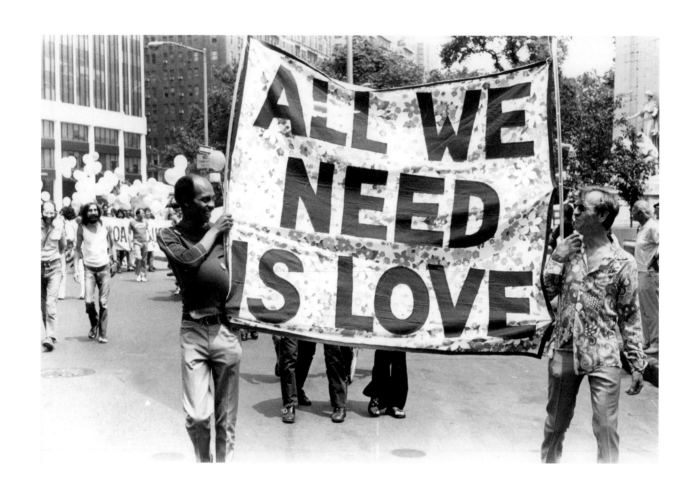

Columbus Circle, June 24, 1973.

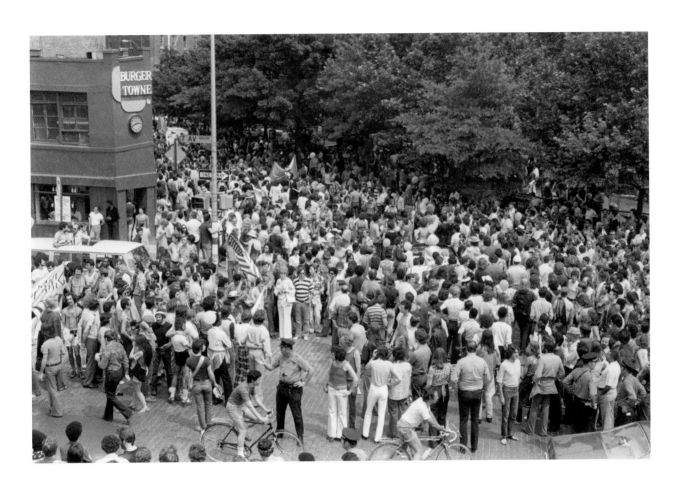

Christopher Street at Seventh Avenue South, across from Christopher Park. June 24, 1973.

Opera star Eleanor Steber, photographed on October 1, 1973, was one of the many celebrities who performed at the Continental Baths during their peak years. The baths were closed down a year later.

The Continental Baths, December 19, 1973.

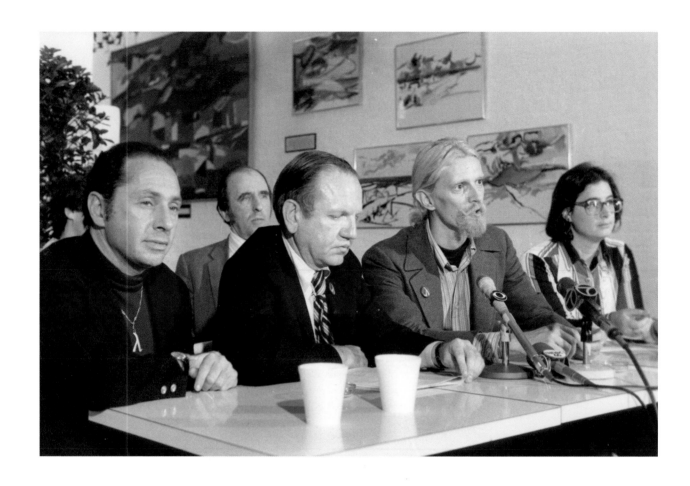

Announcing the formation of the National Gay Task Force, which sought to bring gay liberation into the mainstream of the American civil rights movement. October 15, 1973. L to R: Ron Gold, Frank Kameny, Dr. Howard Brown, Bruce Voeller, Nathalie Rockhill. Former health administrator Brown was the first New York City official to come out.

"[Lambda's] goal was to be as forceful and important as the NAACP legal defense fund or the NOW legal defense fund were to those movements. I think we did pretty well."
—Tom Stoddard, founder, Lambda Legal

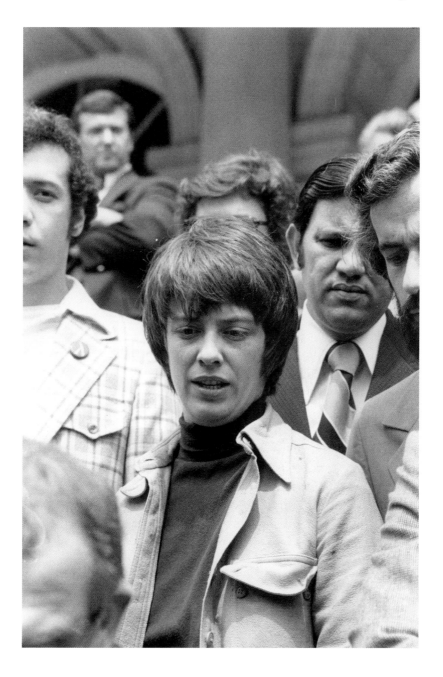

Jean O'Leary, on the steps of City Hall, on April 30, 1974. A former nun, O'Leary was a leader of the National Gay Task Force.

1974 March

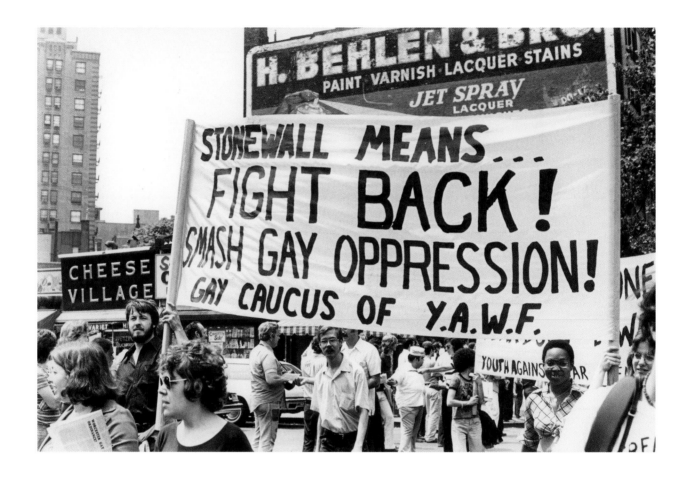

"One of the major slogans of the gay movement is going to become the words '50 percent'—50 percent of everything. If we really believe to the core of our beings that so-called homosexuality is just as valid, just as good, just as life-giving, life-affirming as heterosexuality, then we have to believe that in the future, especially when parents and the state stop brainwashing their children, that when people have a free choice in the matter of their sexual orientation that at least 50 percent of the people are going to be gay."

—Craig Rodwell, Oscar Wilde Memorial Bookshop

Fifth anniversary Stonewall banner carried by members of Y.A.W.F. (Youth Against War and Fascism), June 3, 1974.

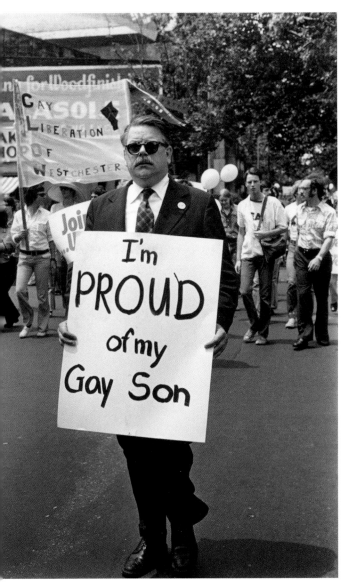

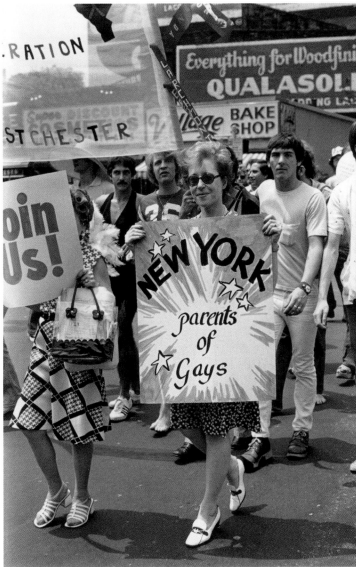

Dick Ashworth, a founding member of Parents and Friends of Lesbians and Gays (PFLAG), marching on June 3, 1974. His sons Tucker and Eric later died of AIDS.

Jeanne Manford, a founding member of PFLAG, June 3, 1974.

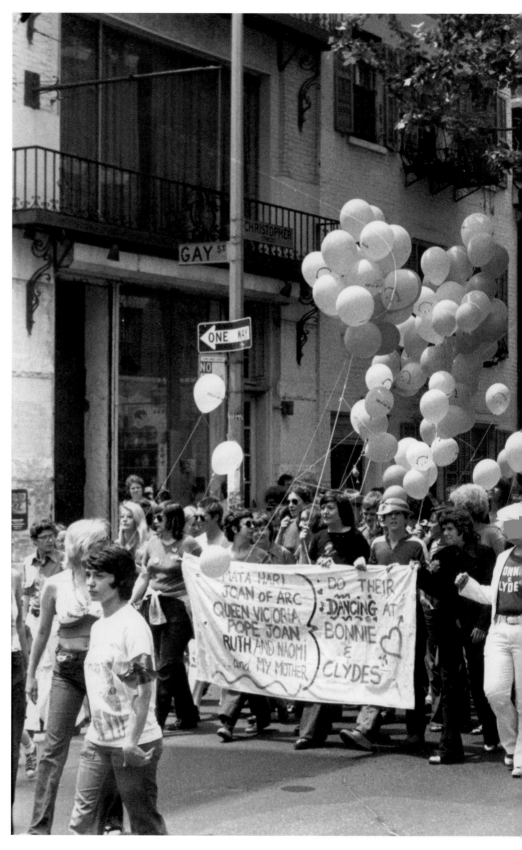

June 3, 1974.

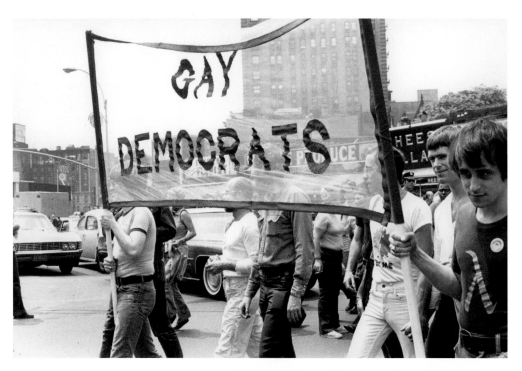

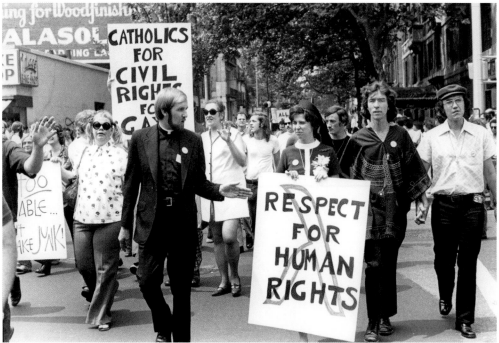

Gay Democrats Jim Owles and Allen Roskoff hold their banner at the march, June 3, 1974.

Reverend Declan Daly and Sister Jeannine Gramick, Catholic leaders and members of Dignity, supporters of gay rights, June 3, 1974.

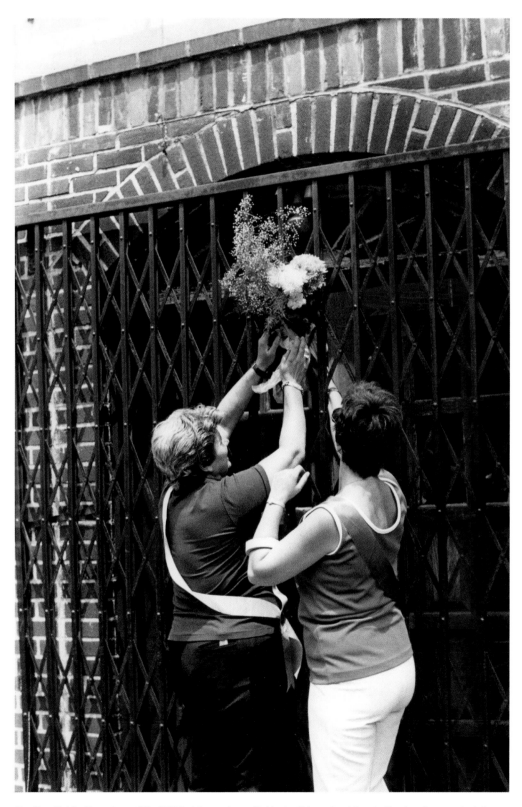

On Gay Pride Day, June 30, 1974, Mama Jean DeVente (L) and a friend attach a bouquet at the Stonewall doorway to commemorate the fifth anniversary of the riots.

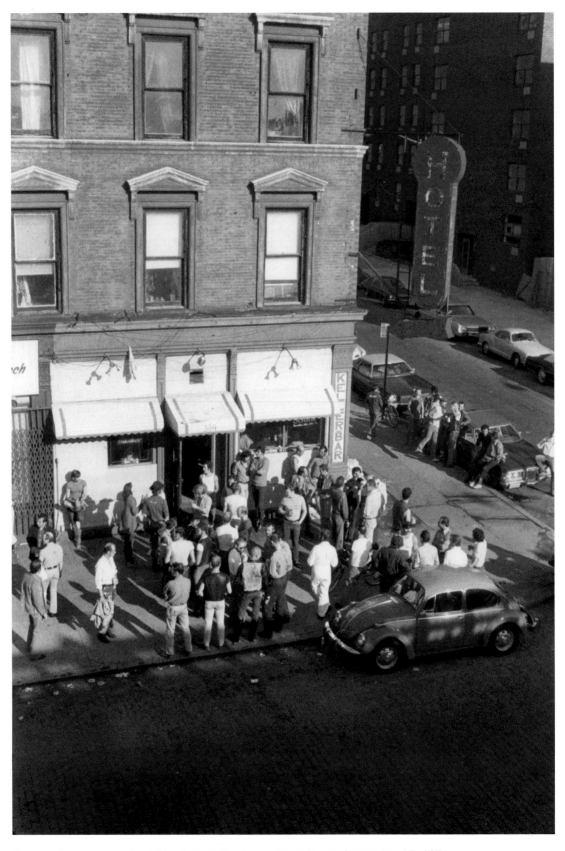

Sunday afternoon crowd outside of the Keller Bar on West Street, September 15, 1974.

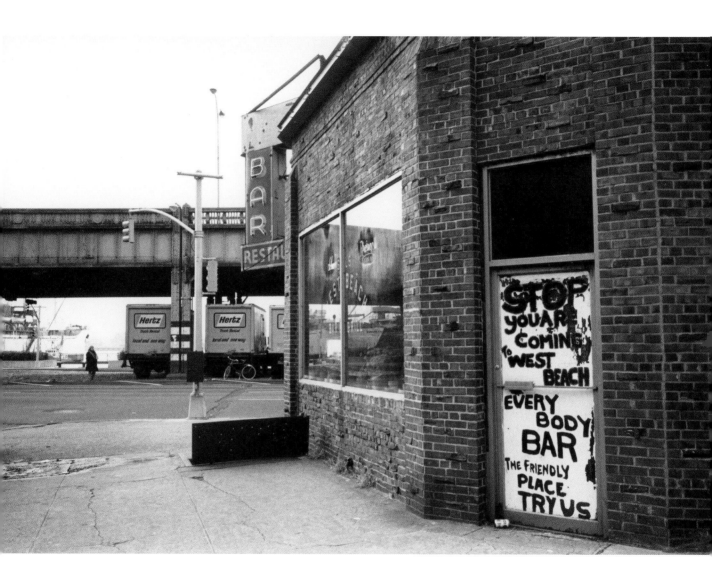

The West Beach Bar, January 27, 1975. In the early '60s, it was called the Fo'c'sle, and then became Dirty Dicks, run by Eddie "Skull" Murphy. It was the only bar in town that featured both dancing and costumes, with everything from transvestites to leather. It thrived during the '70s as the West Beach Bar, despite the fact that occasionally a customer was murdered. In the '80s, it was called Badlands; in the '90s, it became a video store.

1975 March

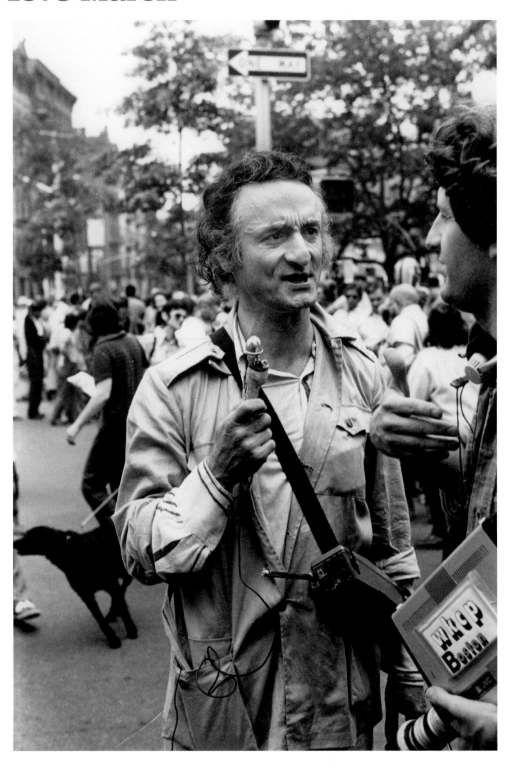

Artist Larry Rivers at the Gay Pride parade, June 27, 1975. Rivers had a long-term relationship with poet Frank O'Hara and delivered the eulogy at O'Hara's funeral.

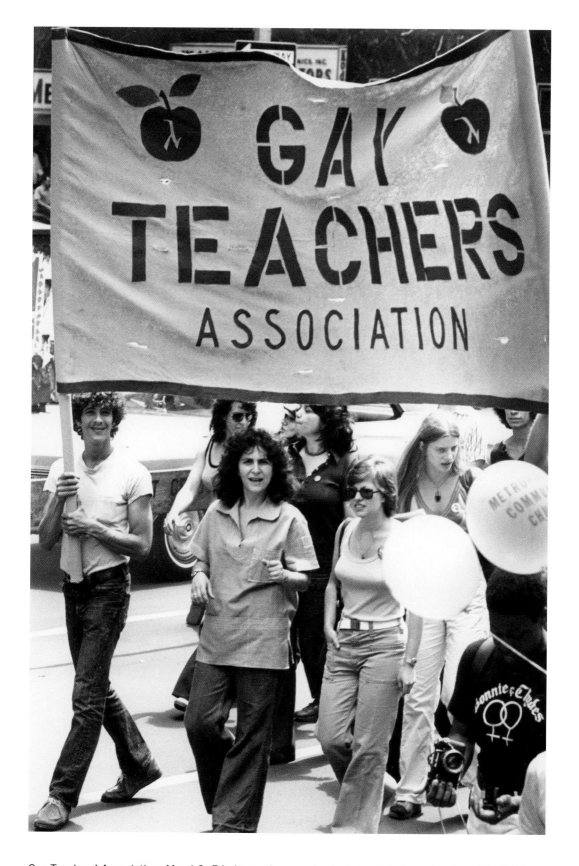

Gay Teachers' Association; Meryl C. Friedman, the organization's head, is in center. June 29, 1975.

"From his early days with the Gay Activists Alliance to cofounding Act-Up and GLAAD to his final days fighting for his own life, Vito [Russo] was always . . . at the forefront of the battle for justice. His activism inspired thousands, including me. During times when it was difficult to have faith in 'leaders' it was always easy and comforting to have faith in Vito."

<div align="right">–Lily Tomlin</div>

Writer, film historian, and activist Vito Russo at the Gay Pride March, June 29, 1975. He wrote *The Celluloid Closet,* a landmark exposé of Hollywood's homophobia.

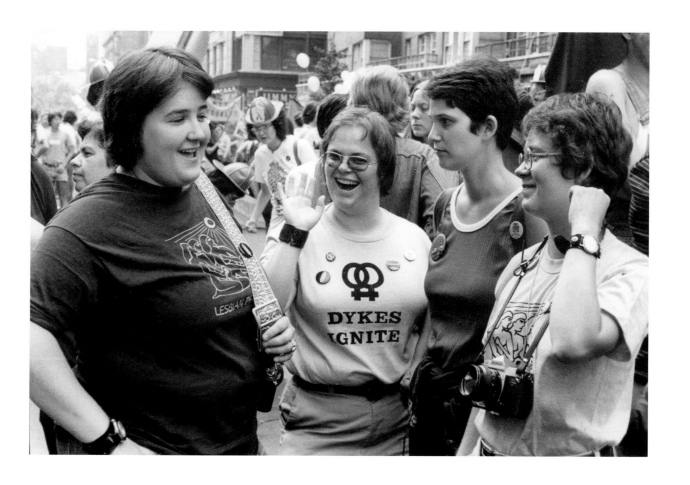

June 29, 1975.

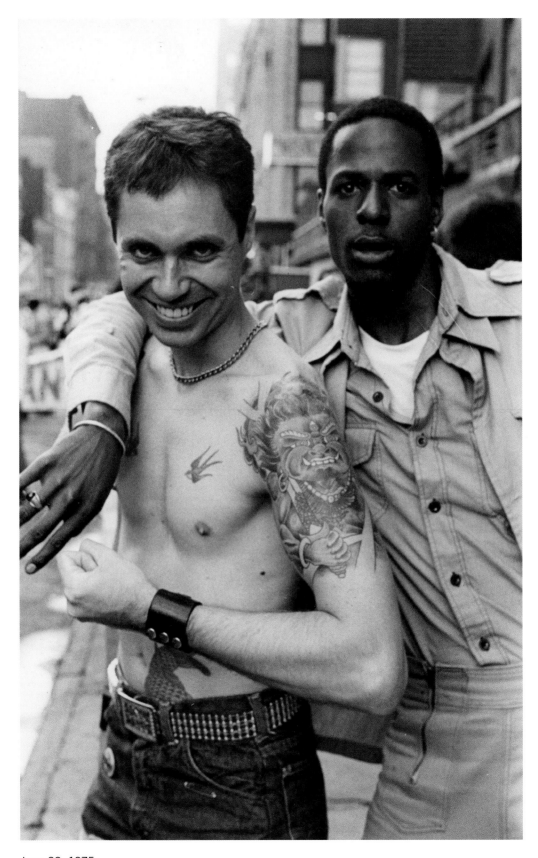

June 29, 1975.

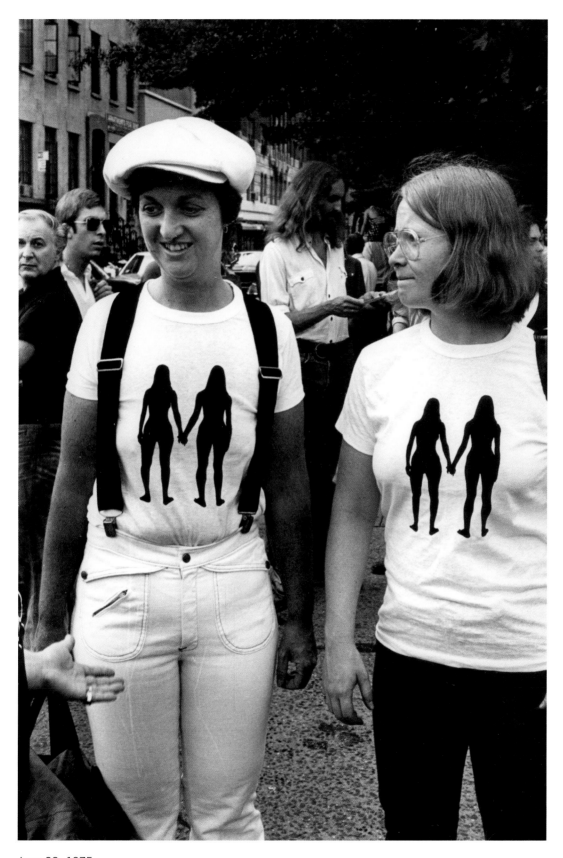

June 29, 1975.

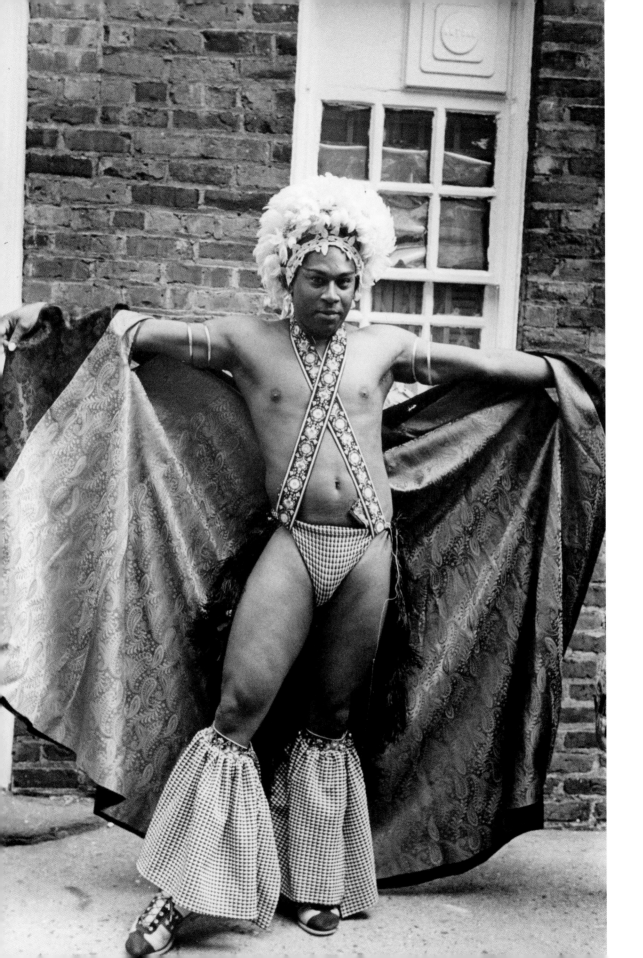

"At first, I thought the gay liberation movement would turn the Village into a ghetto. To me, everything was much sexier before the riots, the clandestine aspect of everything excited me. It was much sexier to sneak around, don't you think? I liked it before everyone wore mustaches and combat boots and started going to bed with their own lookalikes. That isn't very fun. When everyone and everything came out it all became so indiscriminate, with people doing people in the back rooms of bars. Unfortunately, too many people wound up with AIDS from that.

"But don't misunderstand me. It was a necessary movement nevertheless. I myself was picked up by detectives twice that I remember in the '50s and wound up in the Tombs. That was a horrifying and humiliating experience. It happened to thousands of us, I'd imagine. There had to be a reaction to that and it was the riots and the whole movement.

"The best part is the great political power that homosexuals have amassed since then. Twenty-five years ago, we were barely a blip. Nobody recognized that there was a gay voting bloc. Now, the candidates all come a courtin' to Christopher Street. It's amazing how things have changed."

<div align="right">—Taylor Mead, poet and actor</div>

June 29, 1975.

June 29, 1975.

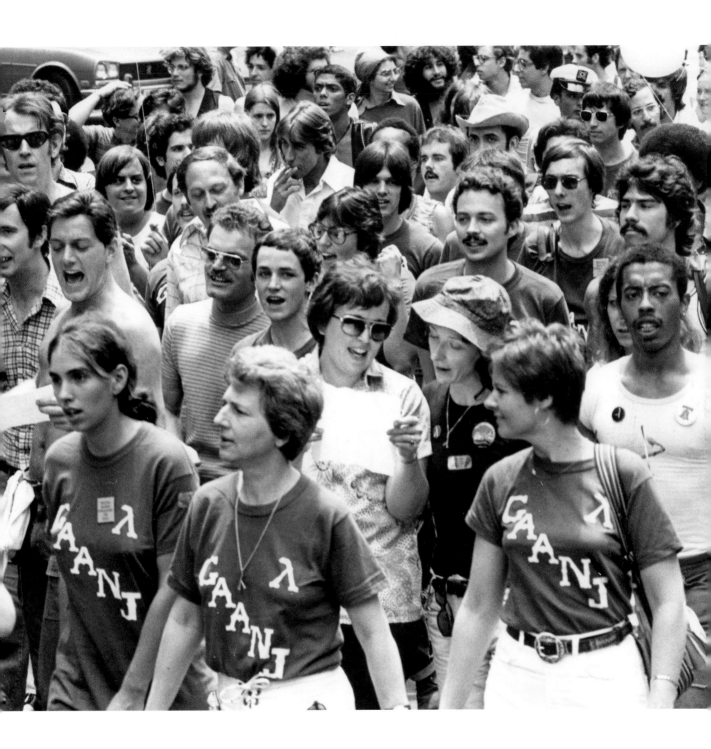

Members of the Gay Activists Alliance of New Jersey, June 29, 1975.

"I have the best job in American Judaism. Friends warned me about taking the job. They feared I was committing career suicide. But Judaism has taught me that it's important to take risks. I think CBST represents much of what is best about American Judaism . . . even if America doesn't know it yet."

—Rabbi Sharon Kleinbaum, Congregation
Beit Simchat Torah (a gay synagogue)

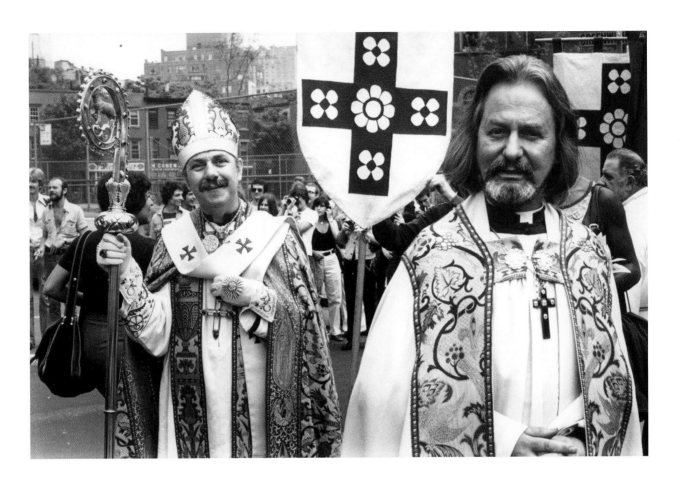

John Noble and Bishop Robert Clement, leaders of the world's first gay church, The Church of the Beloved Disciple, June 29, 1975.

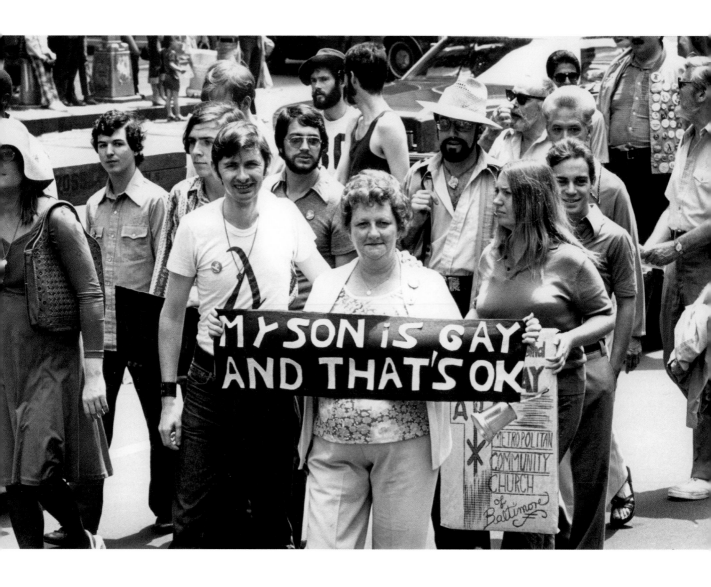

June 29, 1975.

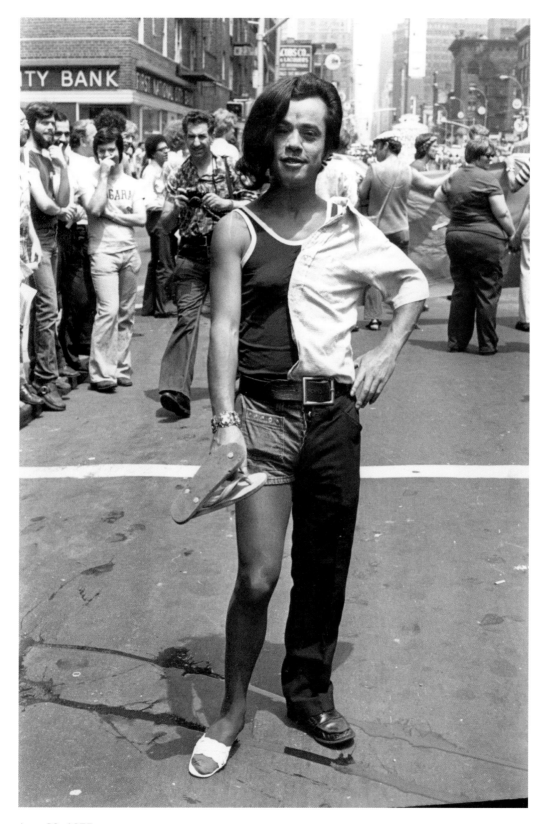

June 29, 1975.

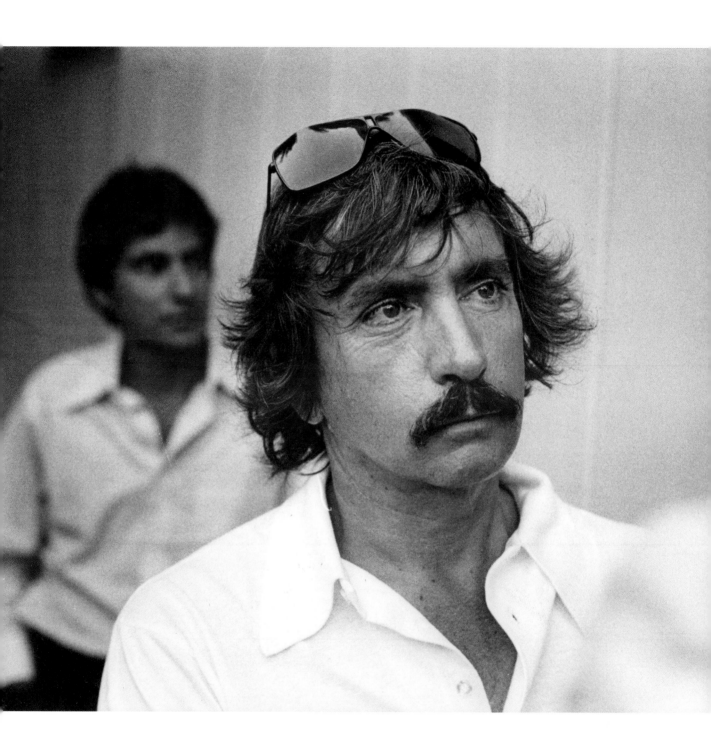

Playwright Edward Albee at a party at the Elaine Benson Gallery in Bridgehampton, New York, July 19, 1975. Albee was a regular patron of Julius' Bar, where the 1966 Sip-In took place. At Julius', Albee met an archaeology professor married to the daughter of the college president, who reportedly was the inspiration for *Who's Afraid of Virginia Woolf?*

"In 1970, the late Marty Robinson of the Political Action Committee of the Gay Activists Alliance (GAA) proposed that the group work for an amendment to New York City's human rights law that would ban discrimination against lesbians and gay men. The movement's emphasis in those heady, combative days was on getting rid of sodomy laws (not accomplished until the state court threw them out in 1980), ending police harassment and entrapment, and expanding gay consciousness, liberation, and social life.

"Even at a time when movements for the civil rights of African-Americans and women were at their height, it was radical to suggest that gay people should receive equal treatment. GAA even had trouble getting liberal city council members from Manhattan to sign on as co-sponsors of the legislation. But several years of relentless militant activism led by the late Jimmy Owles and Morty Manford, among others, paid off in 1974 when the sexual orientation bill was voted out of the General Welfare Committee 7-1. No bill in the city's history had ever been approved by committee and lost on the floor of the full council. Thanks to a vicious campaign led by the Roman Catholic Archdiocese of New York, this one was rejected.

"The church had a stooge in Thomas Cuite, the council majority leader, who ruled with an iron hand. Cuite promised Cardinal Cooke that the bill would not see the light of day, and he succeeded in keeping that pledge despite the support of all city officials, the governor, the major newspapers, and public opinion polls.

"The Coalition for Lesbian and Gay Rights brought gay and mainstream groups together to work for passage. The Gay Rights Bill was a subject before city council members twenty-eight times beginning January 6, 1971, but was always defeated. Even these losses, however, produced memorable moments. Bob Livingston, the city's first openly gay Human Rights Commissioner, on the verge of death in 1981, struggled to the podium at the public hearing to promise, 'We will be back again and again and again.' Sergeant Charles Cochrane, NYPD, also testified in 1981, saying, 'I am proud to be a police officer. And I am equally proud to be gay.' Betty Santoro, of Lesbian Feminist Liberation (LFL), the lead testifier in 1983, asked, 'Do we have to stand here bleeding before you to convince you that we have suffered enough to deserve our rights?' David Rothenberg in 1981 spoke of a horrific incident the year before when four gay men were gunned down in the Village outside the Ramrod Bar by a crazed antigay bigot.

"But in 1986—well into the reign of Ronald Reagan and the dispiriting AIDS crisis—all those years of bitter struggle paid off. With the emergence of a gay

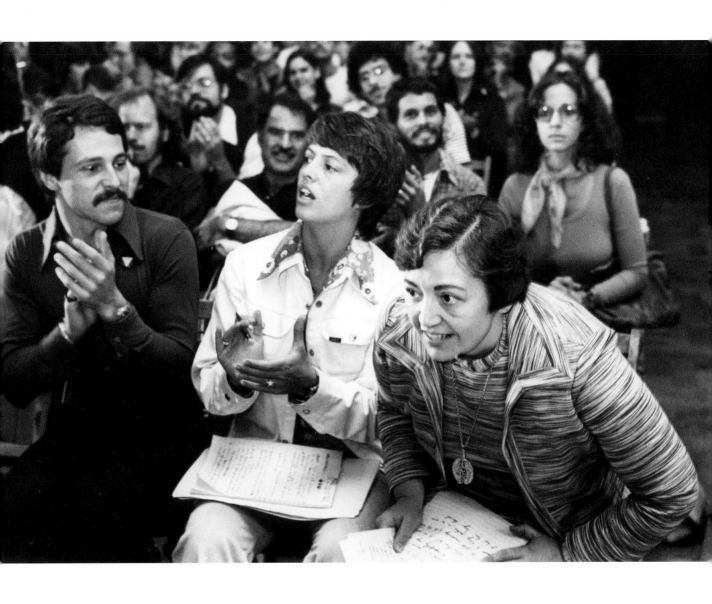

Jean O'Leary and Lieutenant Governor Mary Ann Krupsak at City Hall supporting the Gay Rights Bill, September 11, 1975.

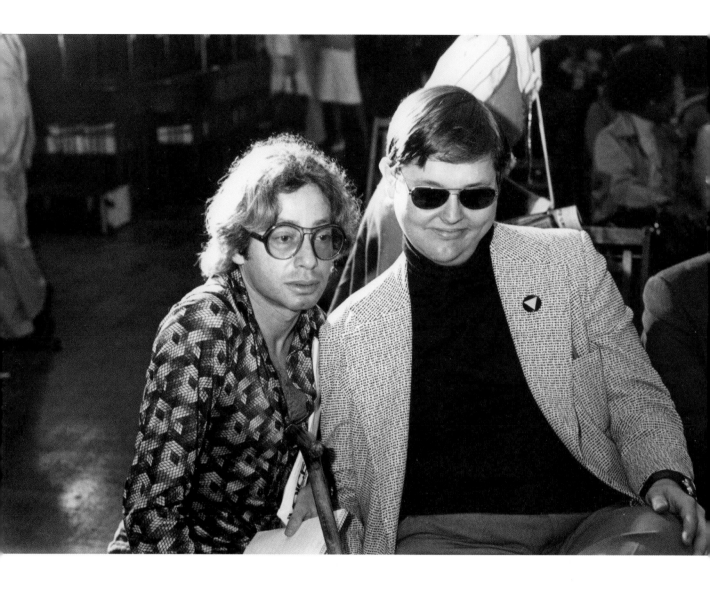

Arthur Bell, founding member of the Gay Activists Alliance and newspaper columnist for the *Village Voice,* along with *Voice* media critic Doug Ireland, September 11, 1975.

political action committee (FAIRPAC) and gay political clubs in every borough, a new council had been elected with a bare majority committed to vote for the bill. Lambda Legal Defense's Tom Stoddard drafted a new version of the bill, clarifying its intent without watering it down. The new Catholic archbishop, John O'Connor, upheld his group's tradition of bigoted opposition, but he was more than counterbalanced by the common decency of religious leaders such as Episcopal bishop Paul Moore, Rabbi Balfour Brickner, and, in his own church, Sister Jeannine Gramick, Reverend Bernárd Lynch, and the members of Dignity.

"We took nothing for granted. Thousands of letters supporting the Gay Rights Bill were piled on council members' desks. Gay leaders as diverse as Allen Roskoff and Jim Levin worked together in common cause. Political consultant Ethan Geto worked the inside while lesbian leader Eleanor Cooper organized the grassroots. The Gay and Lesbian Alliance Against Defamation emerged to help with street activism. On March 11, the bill passed commitee 5-1. And on March 20, 1986, after fifteen years of struggle, the bill in full council passed by a 21-14 vote, with Council Member Ruth Messinger casting the deciding vote.

"But the United States Supreme Court dealt us a setback almost immediately, in June, 1986, when it ruled 5-4 in the infamous *Bowers v. Hardwick* decision that state laws prohibiting consensual sex between members of the same sex were constitutional, reminding us that we have a long way to go before enjoying equal justice in the land of the free.

"In 1971, New York City was the first to propose protecting civil rights on the basis of sexual orientation. When the Gay Rights Bill passed in 1986, many jurisdictions had codified gay rights, and several, including Dade County, Houston, and Wichita, had repelled them through referenda. Today, eight states—Wisconsin, Vermont, California, Massachusetts, Hawaii, Connecticut, New Jersey, and Minnesota—but not New York—protect gay rights, as do hundreds of cities and counties. These laws are the prime target in the religious right wing's nation-wide effort to seize political power by attacking 'special rights for homosexuals.' We always knew we were special. We have never wanted anything more from the government, however, than equal treatment under the law.

"Many of the visionaries who conceived of a 'gay rights law' and worked for its passage here in New York City are gone—burned out, retired, or dead from AIDS or other causes. They can rest in peace knowing that the revolution they started, while far from over, has spawned a generation that is growing up protected by the law and much freer to help everyone understand what gay liberation is all about."

—Andy Humm, *Cable News Network*

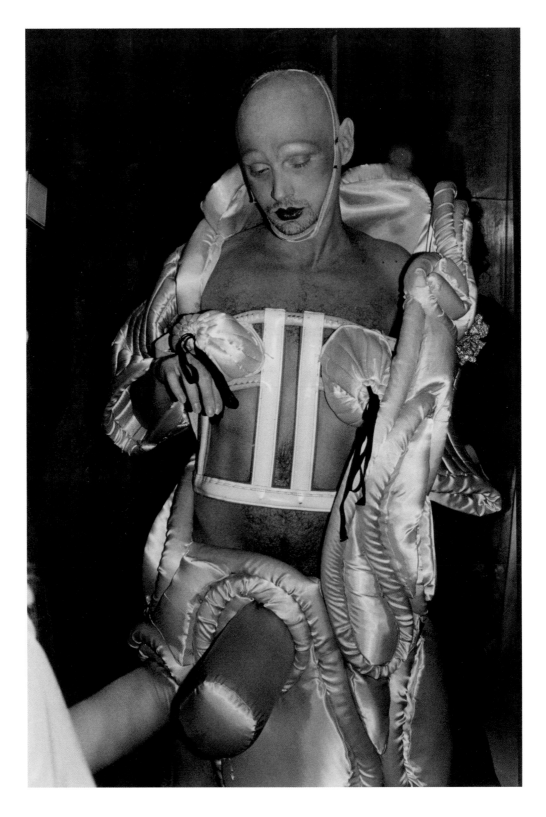

Performance artist and playwright Stephen Varble on December 2, 1975, in an appearance at the Rizzoli Bookstore.

Charles Ludlam, the director, playwright, and leading actor of the Ridiculous Theatrical Company, March 13, 1976. He produced over thirty shows before his death in 1987, at age 44, of AIDS. His legacy includes *Camille*, *Bluebeard*, *Le Bourgeois Avant-Garde*, *Galas*, and *How to Write a Play*.

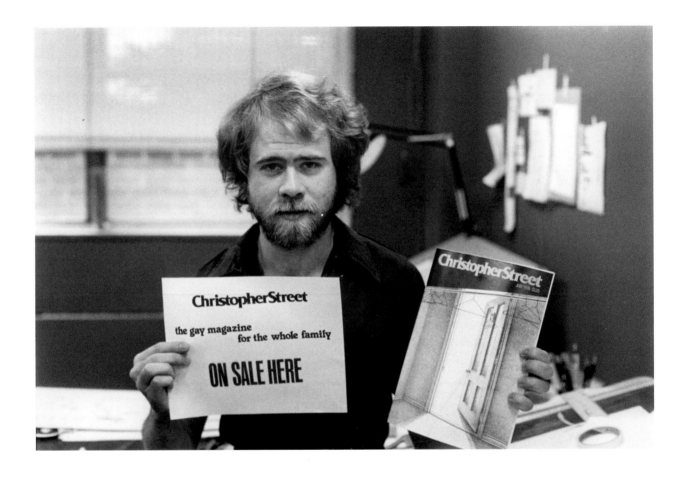

"I don't know if it's something you just find out. I guess I had thought about it as a kid. But I didn't really try it until I was in Pittsburgh, when I was twenty. The first time I didn't really like it. Then I started finding people that were nicer and more my age and more into what I was interested in."

—Keith Haring

Charles L. Ortleb, publisher of *Christopher Street*, holding the first issue on May 26, 1976. He called it "The Gay Magazine of the Whole Family," meaning that it featured no pornography or beefcake photos.

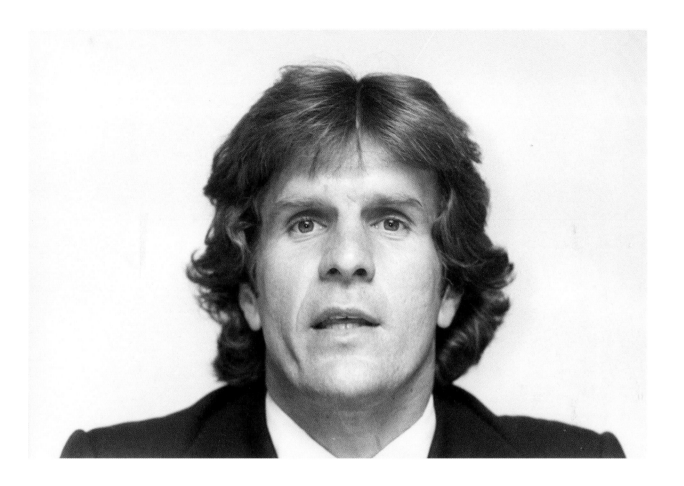

Ex-NFL player David Kopay, photographed March 4, 1977, at a press conference announcing he was gay. He was the first professional athlete to do so. After his retirement, he hoped to work as an athletic coach: "No one would hire me . . . They didn't think I could fill the role of coach as guardians of the morals of the young students."

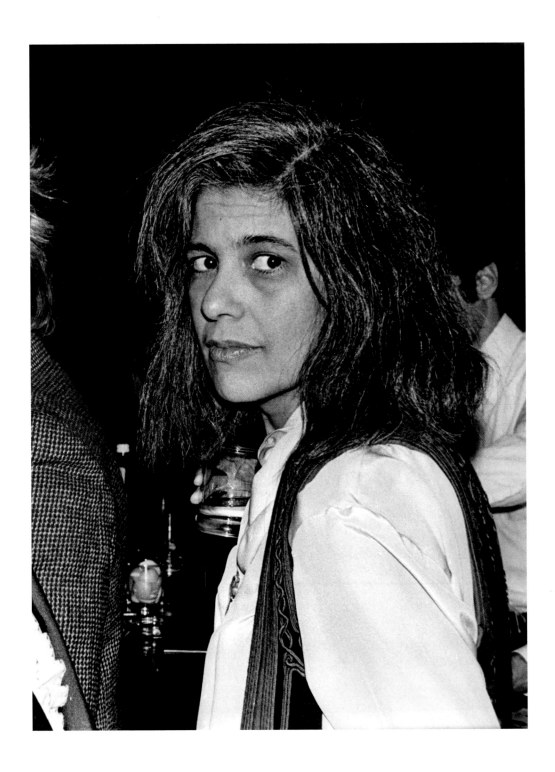

Susan Sontag, one of the most influential critics of her generation, at a party to memorialize the life and work of author James Jones, and the posthumous publication of his novel *Whistle*, at the Park Avenue Armory, February 22, 1978. After a 10-year marriage and giving birth to a son, Sontag went on to have several significant female relationships in her lifetime, including with playwright María Irene Fornés, and she spent the last fifteen years of her life with photographer Annie Leibovitz.

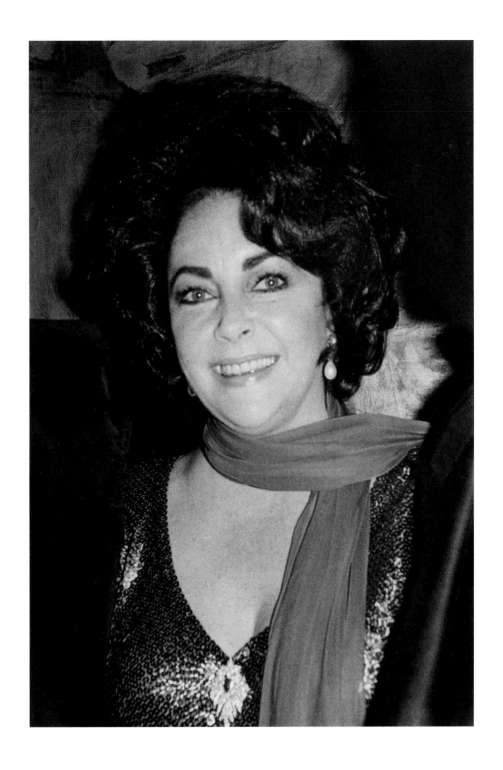

Elizabeth Taylor, March 6, 1978. Rock Hudson's death, along with the diagnosis of her daughter-in-law, Aileen Getty, with AIDS, galvanized Taylor into becoming one of the leading fundraisers for AIDS research, as well as a spokesperson for people with the disease.

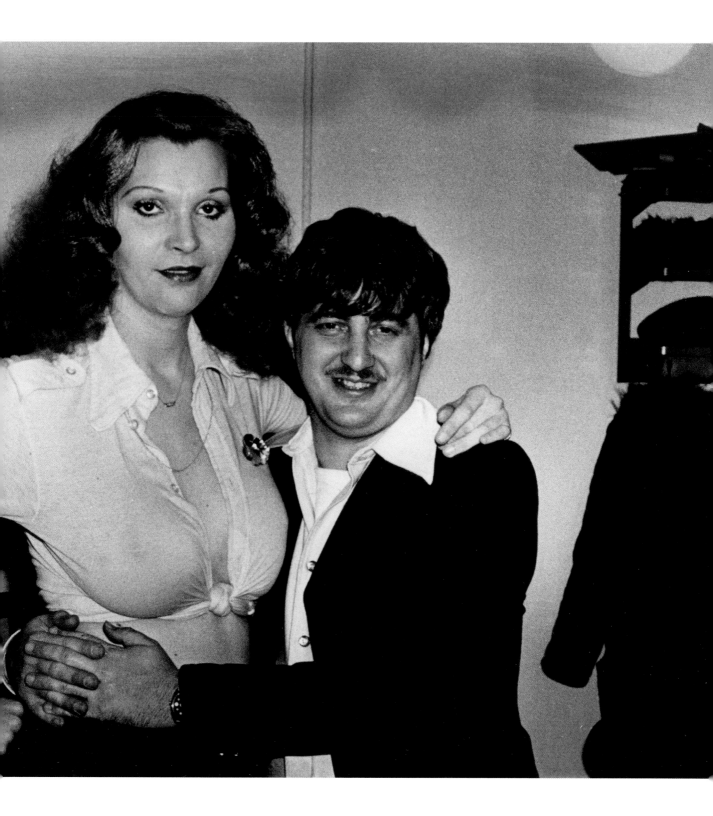

Liz Eden and Littlejohn Wojtowicz, March 2, 1979. They were the subjects of the Sidney Lumet film *Dog Day Afternoon*, starring Al Pacino. Pacino portrayed Littlejohn, who became a news sensation after he held up a bank in Brooklyn to pay for Eden's gender transition.

"I never had any problem about being homosexual. I mean, look at me. I was always right out there. The other kids liked me for that. I was really quite popular. I was amusing and I was pretty. I didn't look like anybody else and I wasn't like anybody else."

—Truman Capote

Writer Truman Capote photographed at a book-signing party, March 21, 1978.

"The idea of declaring your homosexuality seems so simple. I regret I didn't do it earlier in one way or another and I think perhaps I should have. But I never felt that I was concealing it, as far as my own life and my own relations with other people were concerned. In the first place, over a great period of my life I lived in a domestic partnership with some other man, and we've always gone around everywhere together, and there's never been any question about that, so there's never been any question of covering up in any sort of way. That makes a difference."

—Christopher Isherwood

Artist Don Bachardy and writer Christopher Isherwood, March 28, 1979. They lived together as an openly gay couple for thirty-three years.

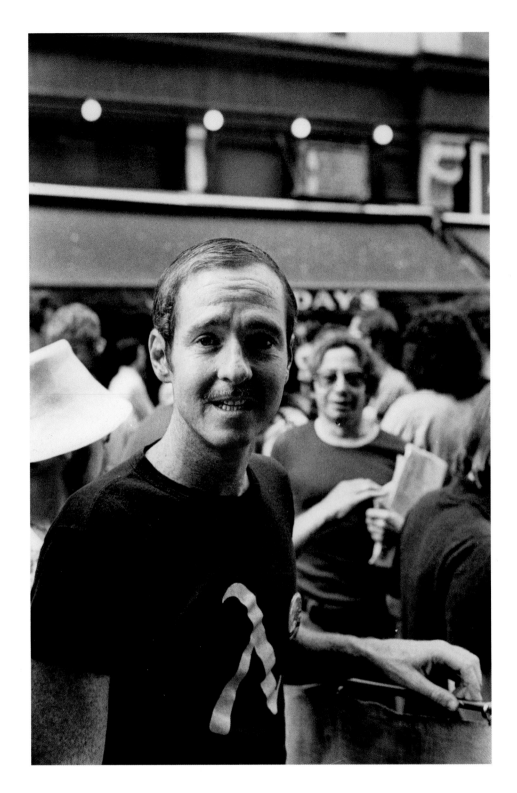

Air force sergeant Leonard Matlovich at the Gay Pride March, June 29, 1979. Matlovich did three tours of duty in Vietnam, and was then discharged for being gay. He was the first gay serviceman to file suit over his discharge, and he was successfully reinstated, collecting $160,000 in back pay. He later died of AIDS.

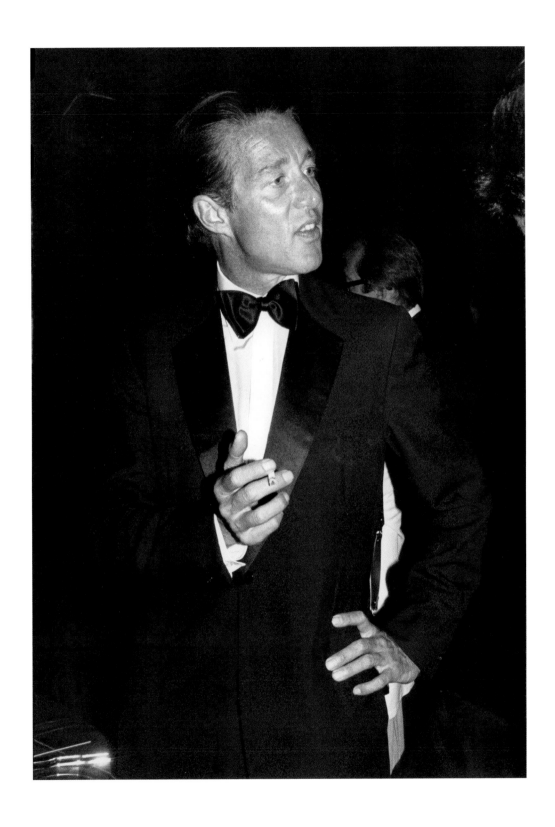

Iconic 1970s fashion designer Halston at Studio 54, September 4, 1979.

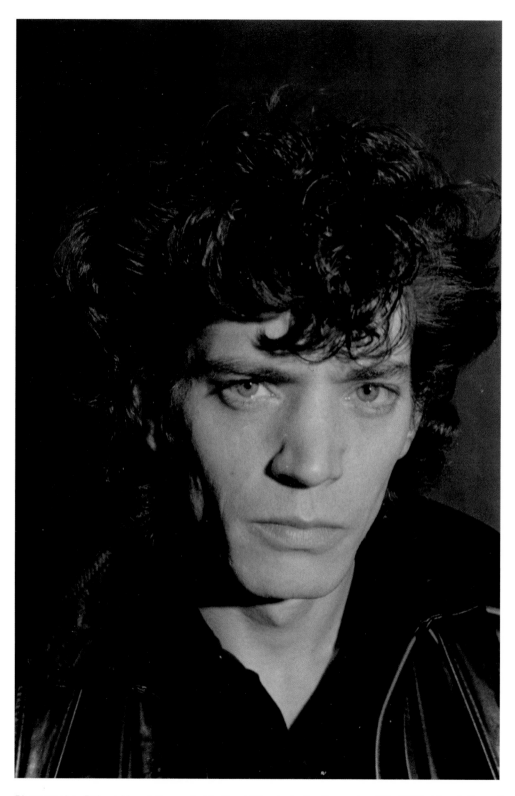

Photographer Robert Mapplethorpe in his Bond Street studio, December 22, 1979. Mapplethorpe's estate donated $1 million to establish a residence for AIDS patients at the Beth Israel Medical Center in New York.

Playwright Tennessee Williams in his West 43rd Street apartment, January 3, 1980.

Actor, singer and drag performer Divine, photographed in his New York penthouse, February 28, 1980. Divine was closely associated with filmmaker John Waters, who featured him in films including *Female Trouble*, *Pink Flamingos*, and *Hairspray*.

"I was talking to John Waters the other day. He told me that if Divine was alive, he'd be jealous of all the attention RuPaul is getting these days. Ru does get a lot of attention, but it's still light-years before Ru or anyone else like him gets their own sitcom, for example. New York and a few other places are enlightened. Much of the rest of the world isn't. The gay movement has come a long way over the last twenty-five years, but there's still a long way to go. Almost every day there is another amazing breakthrough. But since we started pretty late, there's still a long way to go."

<div align="right">

—Michael Musto, former *Village Voice* columnist

</div>

"I have the same vantage on the Stonewall riots as I do on the Boston Tea Party. They were both blows for freedom. Obviously, Stonewall was the beginning of gay people emerging into society as a positive force. But, I'd have to say it has not affected the entertainment industry even one little bit. What major leading men these days are saying that they are gay? Sure, [producer] David Geffen is liberated, but he can afford to be . . . I know there are some well-known leading men and women in the field today who are gay but have not publicly said so. It is a business decision as much as anything else. If they did, they'd be throwing in the towel for future prime acting roles."

<div align="right">—Liz Smith, gossip columnist</div>

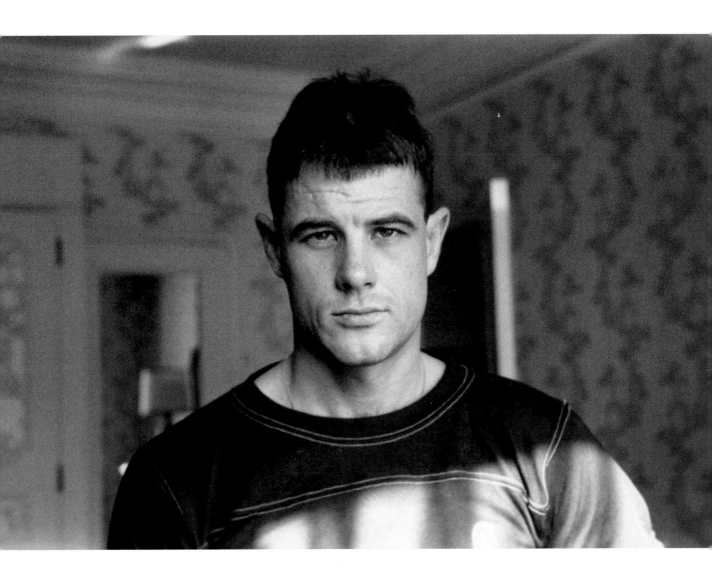

Actor Brad Davis, March 11, 1980. Davis was the French sailor in *Querelle* who goes ashore in the port of Brest to find sex in a brothel, only to discover his own homosexuality. He was in the TV drama *The Normal Heart*, as well as the film *Midnight Express*.

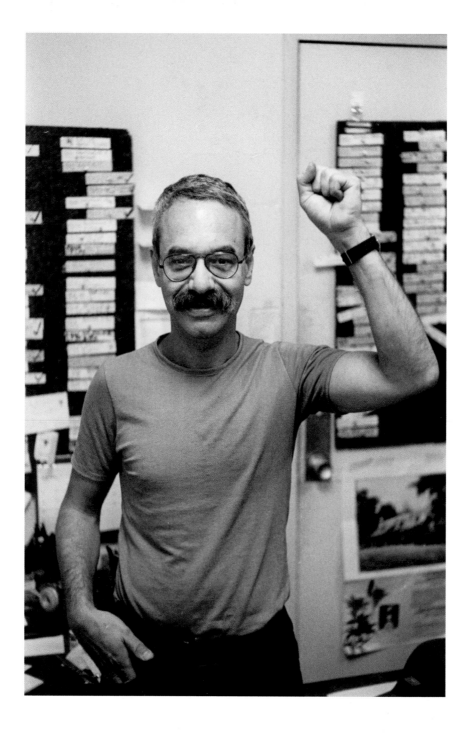

Historian Jonathan Katz, August 2, 1980, in his office. He authored the books *Gay American History* and the *Gay/Lesbian Almanac*, among others.

The Ramrod Bar, November 20, 1980, after the so-called "Ramrod Massacre." *New York Post* reporter Joe Nicholson recalls that a gunman killed four men and injured several others when he sprayed bullets into the popular waterfront bar. "I [wrote] a first-person piece on coming out and about the incident at the Ramrod [for the *Post*] . . . but the story didn't run. The editor told me that there were some concerns over how Rupert Murdoch would react if it were in the paper. Maybe he didn't like gays working for him."

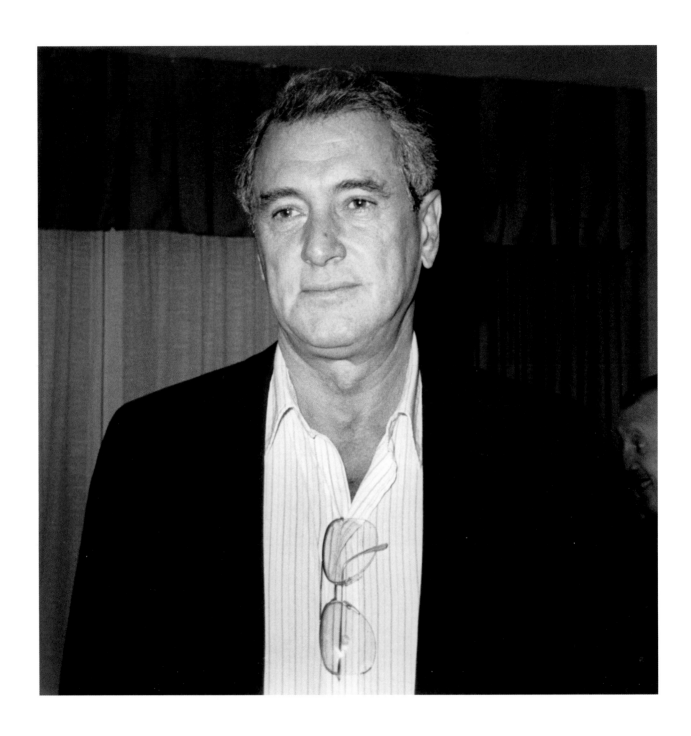

Film actor Rock Hudson, December 16, 1980.

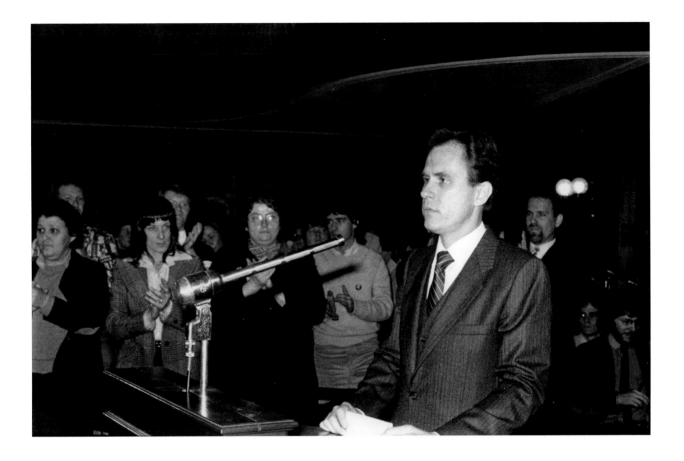

"I'd always known I was gay, although I didn't know the name for it. When I was four, I had a crush on another boy. I thought all people felt that way. When I grew older, I watched my peers start to have interest in women . . . but I didn't. I thought I was just a late bloomer . . . But I waited and I was still interested in boys.

"Eventually, I realized there was something different about me. I was fourteen or fifteen. I had heard the word 'homosexual,' knew what it meant in the dictionary, but that didn't really fit me. Somehow there was so much more involved with it than the dictionary said. There was an emotionalness on my part, and I didn't get that from the dictionary."

<div align="right">—Sergeant Charles Cochrane, NYPD</div>

Sergeant Charles Cochrane, a New York City cop for fourteen years, appeared on November 20, 1981 before the City Council to testify in support of the Gay Rights Bill.

1982 March

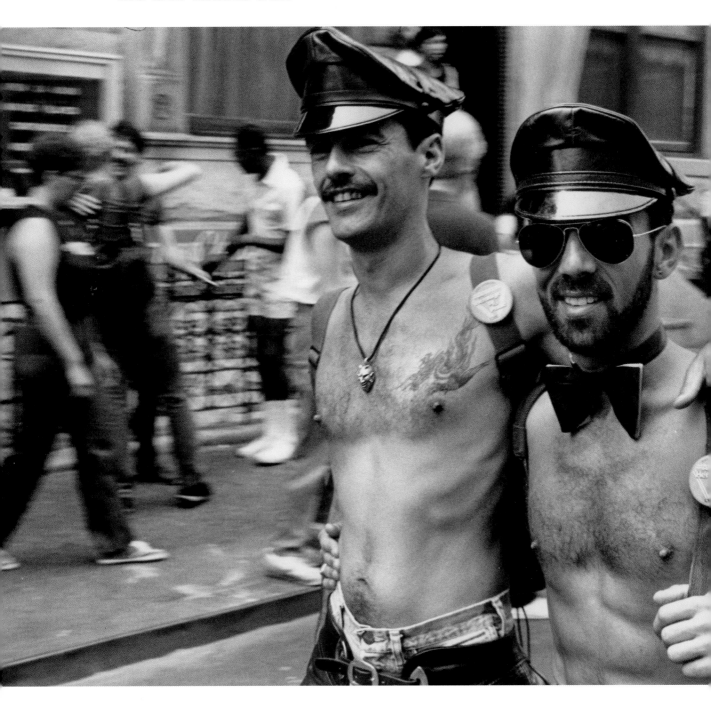

June 27, 1982.

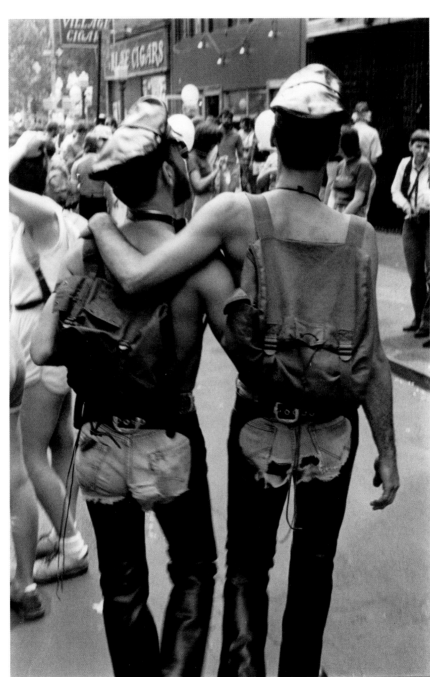

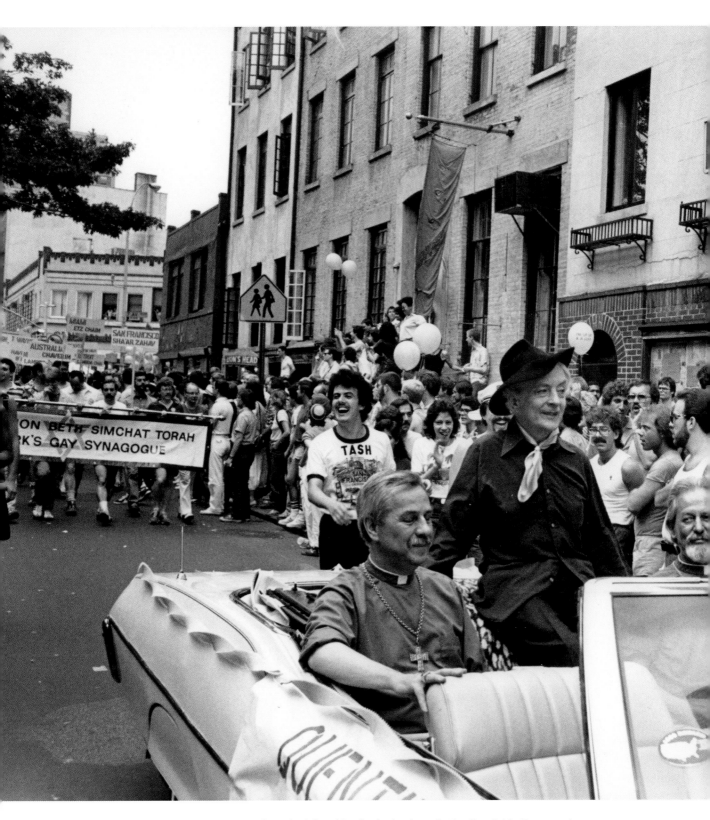

Writer, actor, and raconteur Quentin Crisp rides in the lead car in the Gay Pride Day parade, June 27, 1982, as it passes in front of the old Stonewall Inn. Behind him are marching members of Congregation Beit Simchat Torah, New York's gay synagogue. (The congregation's name is misspelled in the banner.)

"I was riding in a car and I was accompanied the whole way by two policemen with faces like stone . . . I was astounded, really, at how mild the reception for the parade was. People shouted a bit, but not much else. New York has a very Italianate element and Italians love a parade. I bet when they got home late and someone asked them where they were, they said 'a parade.' And when mama asked a parade of what, they said 'I don't even know.'"

–Quentin Crisp

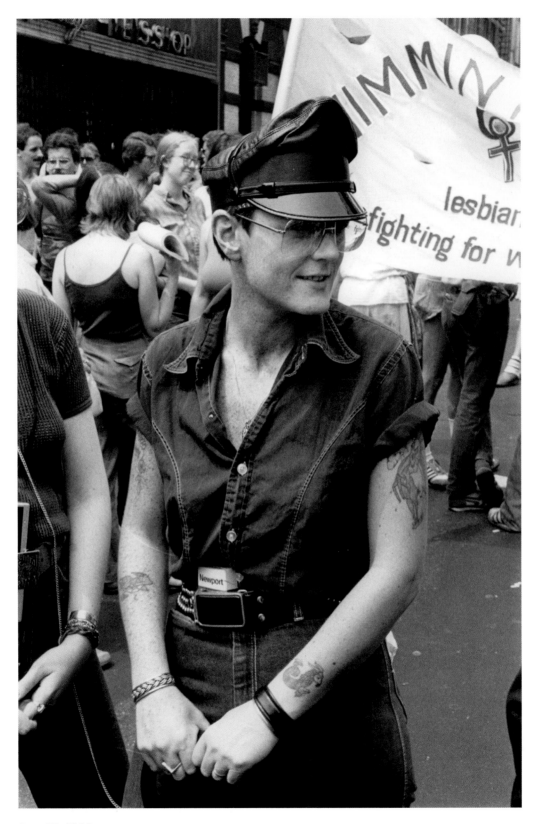

June 27, 1982.

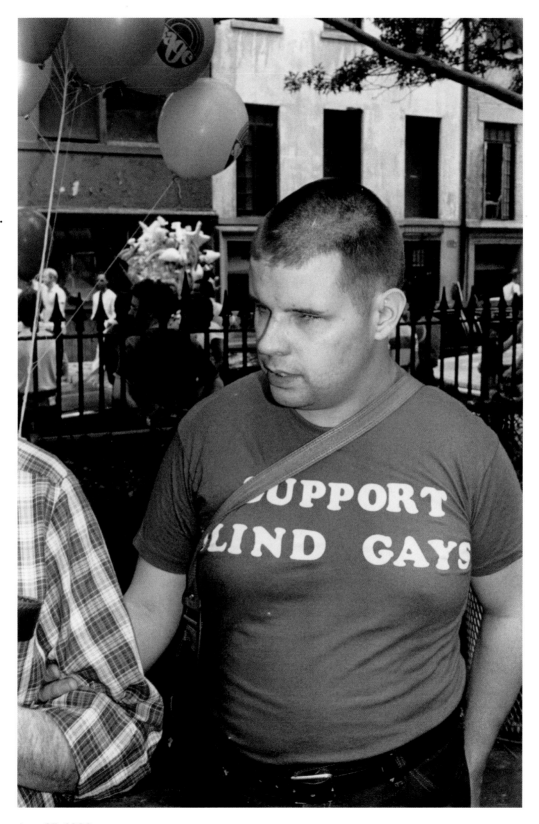

June 27, 1982.

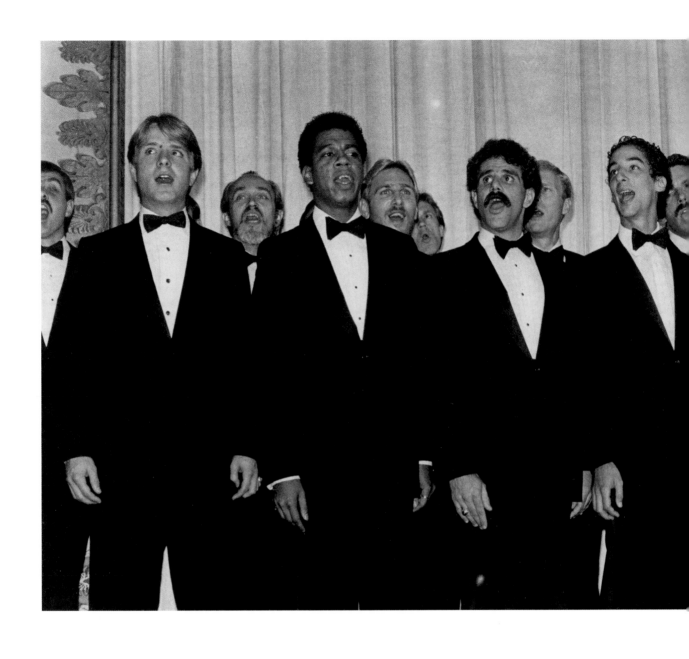

The Gay Men's Chorus, September 27, 1982.

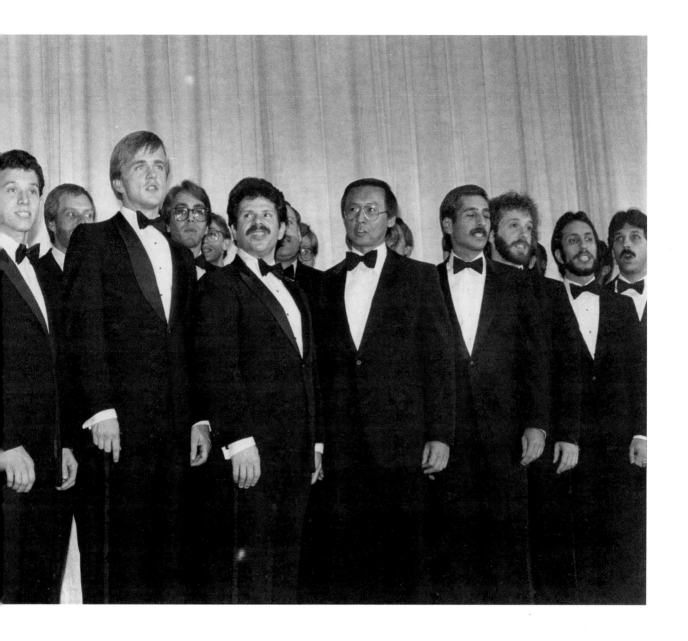

"The Gay Men's Chorus—150 voices strong—has for a dozen years brought lumps to our throats and tears to our eyes with songs of love, pain and courage; smiles to our lips with the lighter numbers; and pride and gladness to our hearts with their sincerity, dedication, and lyricism."

—Bruce-Michael Gelbert, music critic, *New York Native*

Jim Owles, the founding president of the Gay Activists Alliance, on September 29, 1982.
He was the first openly gay candidate to run for political office in New York City in 1973.
Owles envisioned a future in which "homosexuals would show straights that being gay means
something more than baths and bars."

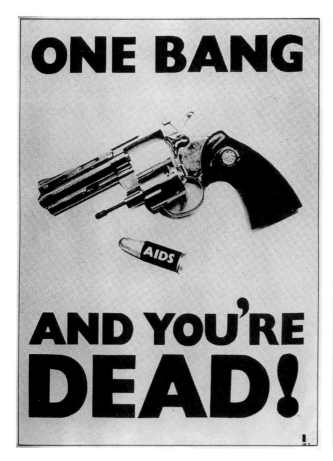

Posters in the London Underground, 1980s.

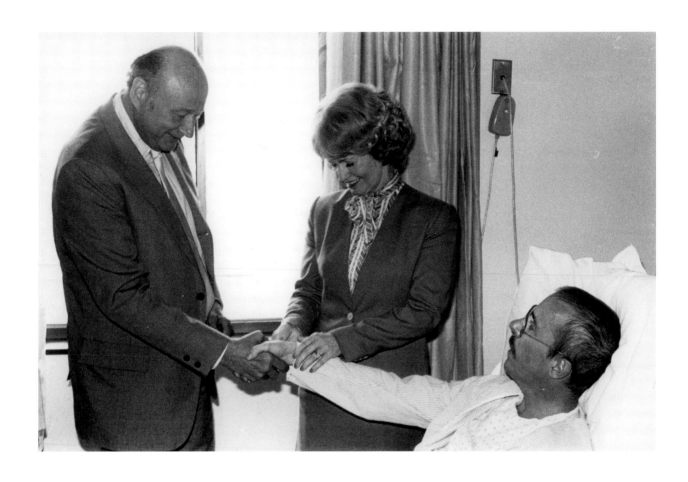

U.S. Health Secretary Margaret M. Heckler and Mayor Koch visit patient Peter Justice at Cabrini Medical Center, August 24, 1983. The center had a fifty-two-bed unit dedicated to treating HIV patients.

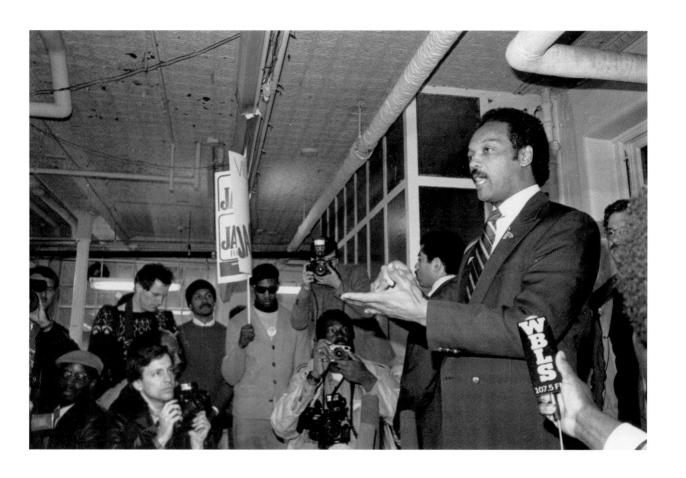

The Reverend Jesse Jackson campaigns for president at the Lesbian and Gay Community Services Center on West 13th Street, March 31, 1984.

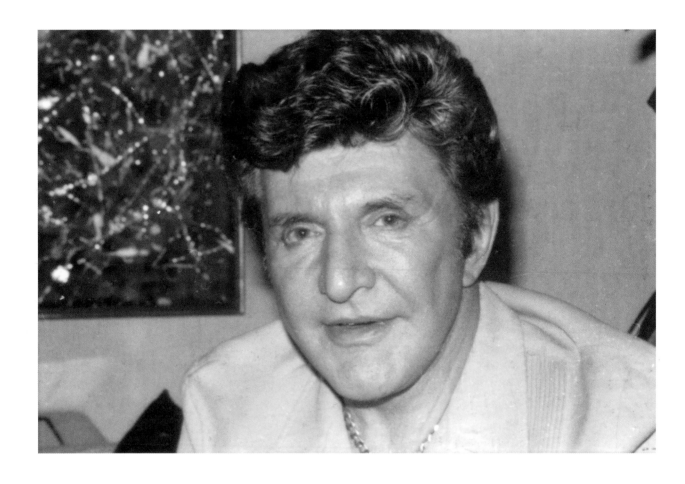

Pianist, singer, and actor Liberace, March 27, 1985: "I find it equally natural to speak of 'Mr. Showmanship' Liberace as if he was another person. The man behind the music, the glamour, the glitz . . . is another Liberace."

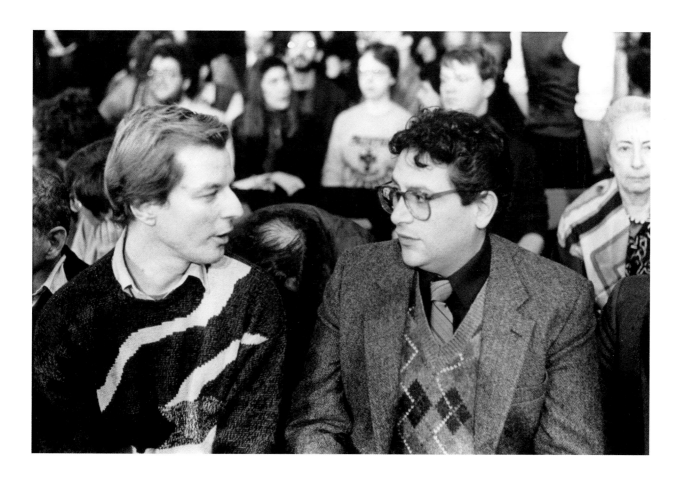

Activist and journalist Bill Bahlman and playwright and actor Harvey Fierstein at a City Council hearing for the Gay Rights Bill, March 11, 1986.

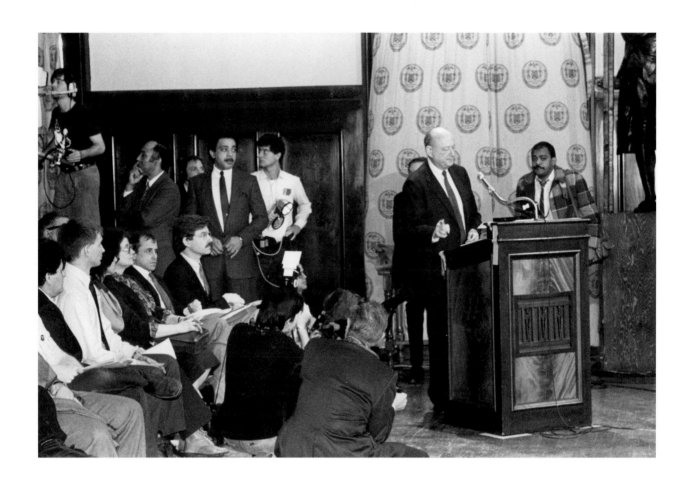

Mayor Edward I. Koch speaking at the City Council hearing in favor of the Gay Rights Bill, March 11, 1986. Seated (L to R): Joyce Hunter, David Gilbert, Eleanor Cooper, Allen Roskoff, Andy Humm.

Nightclub impresario Steve Rubell, with Union Jack on his sleeve, behind the velvet rope at his legendary Studio 54, deciding who will gain entry, February 9, 1978. Closeted for most of his life, he died of complications from AIDS in 1989.

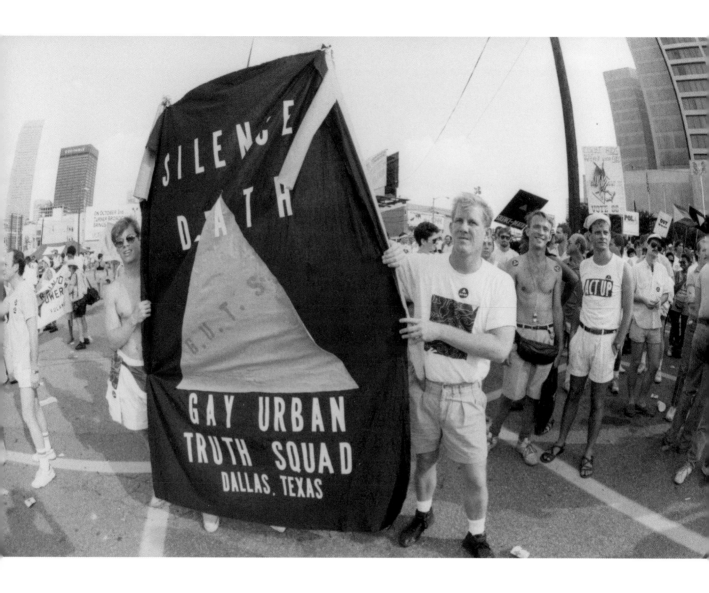

The Gay Urban Truth Squad of Dallas at the Democratic National Convention, July 17, 1988 in Atlanta. The Nazis made homosexuals wear inverted pink triangles as identification, just as Jews were forced to wear yellow Stars of David. In the 1970s, gay activists adopted the pink triangle (seen in the center of the banner) as a way of remembering that gays were one of the many minorities persecuted by the Nazis.

"The decision to come out was the end of a long struggle for me to stop conceding on the private side and having people judge me wholly on the public side. In a political time when things that were once nobody's business have now become everybody's business, it forced me to delve back on my life. People are capable of having messed up careers and wonderfully successful private lives and vice versa. It may be that you would have bad judgment that would negatively affect both. But my answer would be that during the period I was feeling weakest about my private life, people were saying nice things about my public life."

—Former Representative Barney Frank

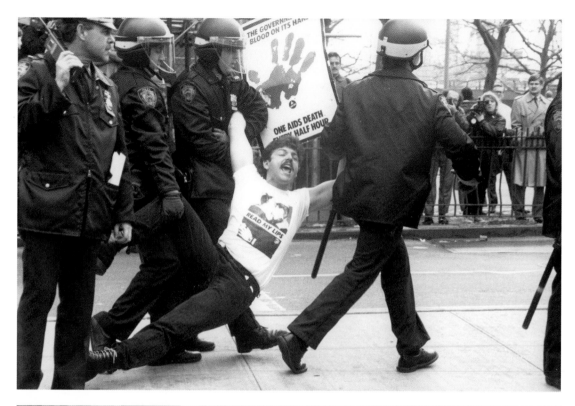

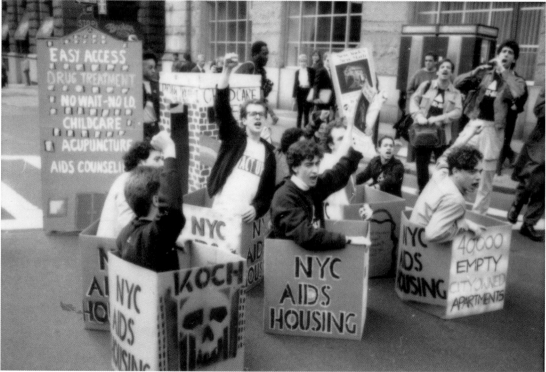

Act-Up demonstrating at City Hall for AIDS housing and counseling, drug treatment facilities, and children's centers, March 28, 1989.

"In March 1990, Tom Blewitt, Michelangelo Signorile, Karl Soehnlein, and myself, all longtime members of Act-Up, got together. It was about the time when Andy Rooney made some cracks about gays to *The Advocate*. We wanted to do something, but we realized that Act-Up was designed to deal with AIDS issues, not this or other antigay incidents. We decided to explore the possibility of doing something more about gay and lesbian issues.

"At our first meeting, sixty people showed up. We were stunned. At our second meeting, eighty-five people showed up. Soon after that someone planted a crude pipe bomb at Uncle Charlie's bar. I think it was on a Friday night. The four of us heard about it Saturday morning. We called everyone we knew. That Saturday night we had twelve hundred people on the street to protest antigay and lesbian violence.

"At the beginning of the day we didn't have a name. Then I remembered a rally protesting the FDA down in Maryland a few years earlier being an ad hoc protest group called Queer Nation. I thought it was funny and provocative. So I took the bullhorn and announced that the rally had been sponsored by Queer Nation. *The New York Times* reported on it the next day and referred to Queer Nation. The name stuck.

"The next really big action drew international press. It was in April and called the first 'queers bash back' demonstration. We marched from the West Village to the East Village and back to the piers. For the first time you saw gays and lesbians fighting back, running after bottle throwers and confronting them. We had about fifteen hundred people that day.

"We've also started a queer shopping network where we have groups travel to nearby malls and hand out leaflets about safe sex. On 'Nights Out,' we go to straight bars, like the old Fluties at South Street Seaport or McSorley's Old Ale House, and try to confront people's stereotypes.

"It really made some of them think.

"There are now about fifty Queer Nation chapters and it is encouraging that many of them are on college campuses. Kids today can be unapologetically gay and they are really affecting pop culture and the future."

—Alan Klein, cofounder of Queer Nation

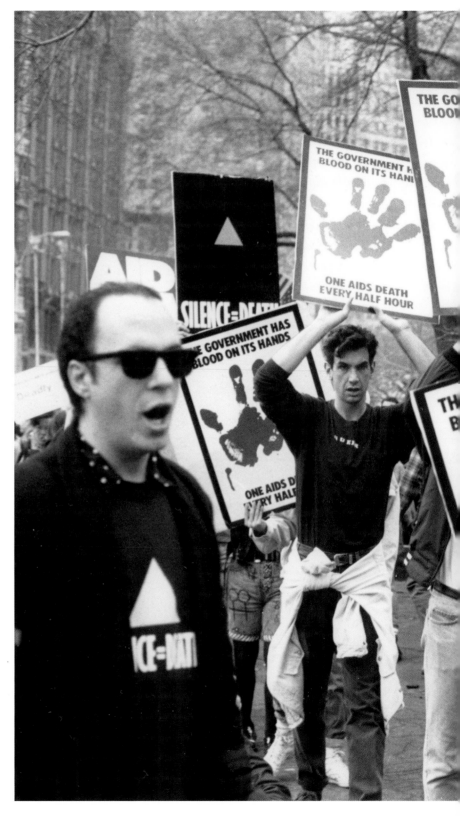

Act-Up poster announces frequency of AIDS deaths, March 28, 1989.

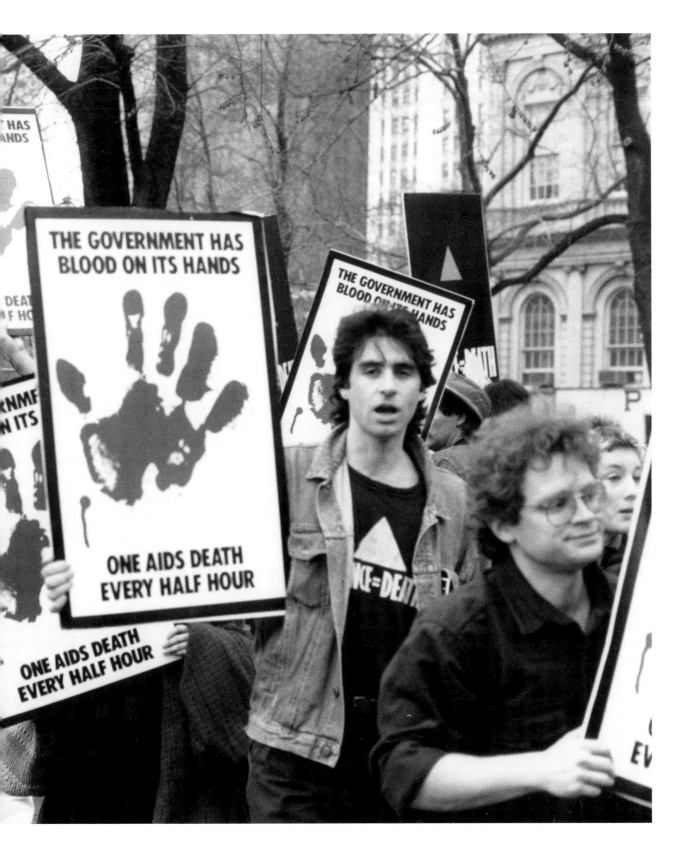

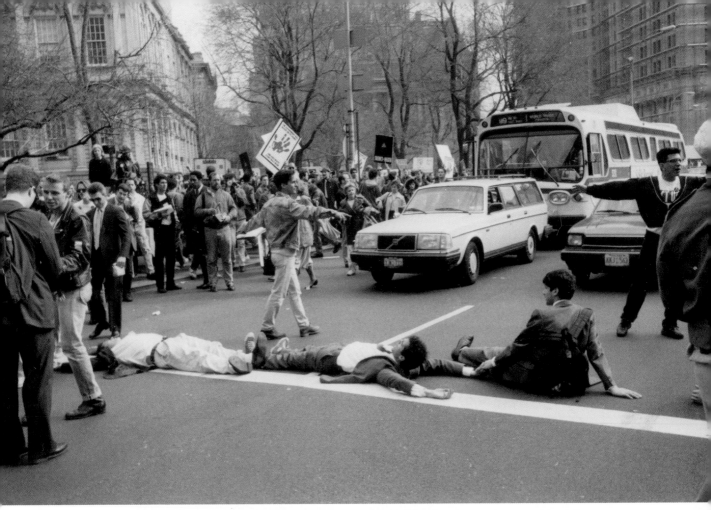

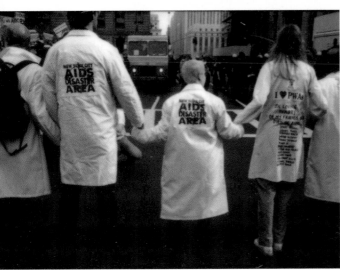

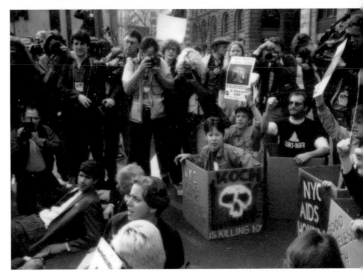

Act-Up demonstrators stopping traffic at the Brooklyn Bridge to create public awareness for the AIDS crisis, March 28, 1989.

Anti-Koch demonstrations, March 28, 1989.

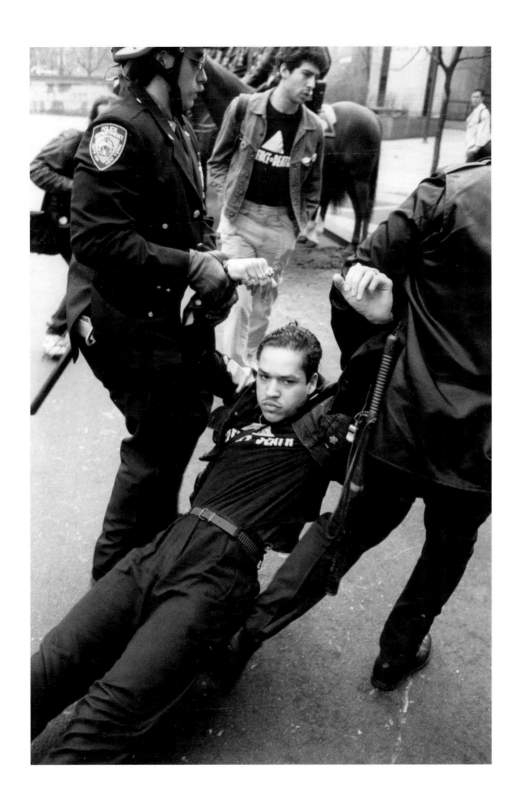

Act-Up demonstrating at New York's City Hall for AIDS housing, March 28, 1989.

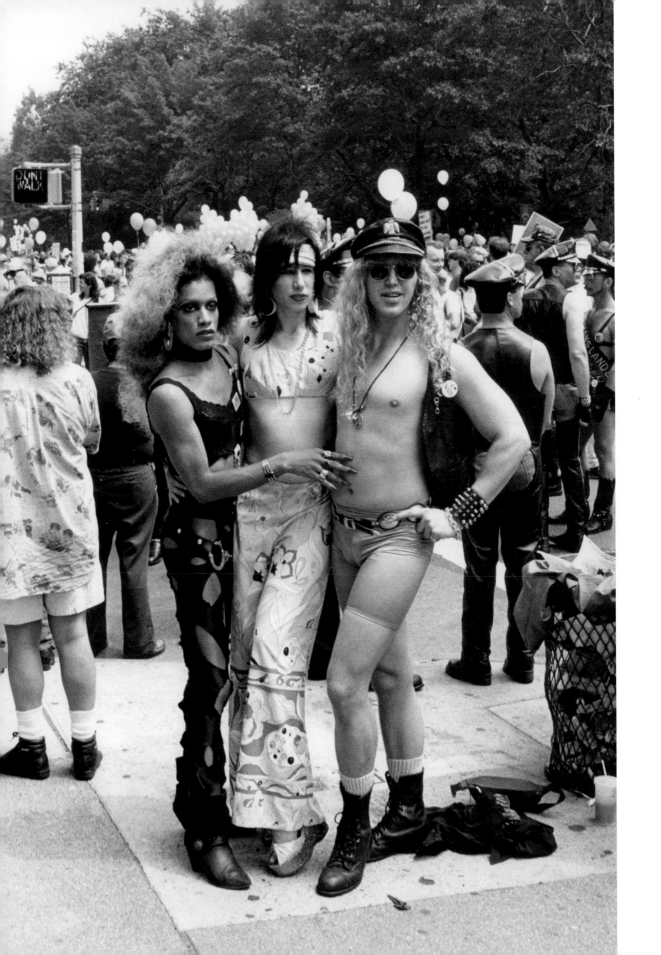

1989 March

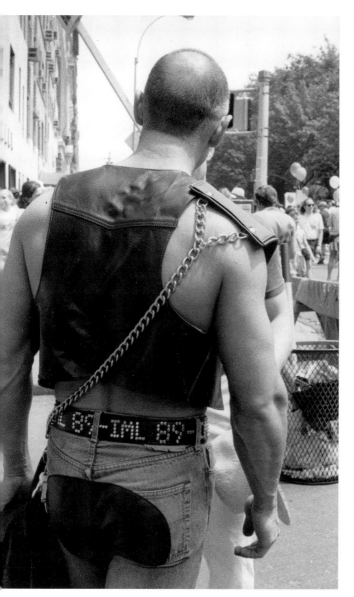 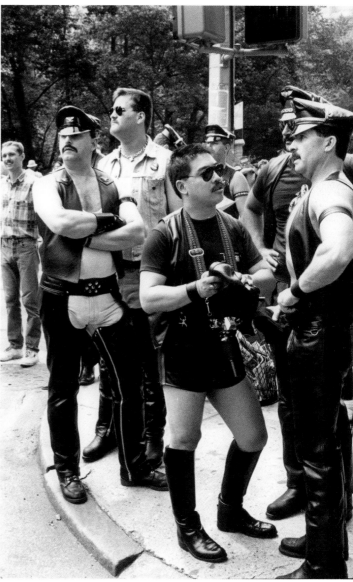

June 25, 1989. Guy Baldwin, 1989's International Mister Leather.

"I came out in 1971 in the pages of *New York* magazine. Looking back, it did not help my career. In a large majority of American cities coverage of gays and gay issues is minimal to nonexistent. So except for a few outlets, gay journalists are not going to come out for fear of losing their jobs, or worse."

—Doug Ireland, journalist

.

"Blacks cover other blacks, women cover other women. If you're a good reporter, your color, gender, or sexuality should not figure into your work. I defy you or anyone else to show me even one example where my personal orientation had any influence whatsoever on my work."

—*New York Times* reporter Jeffrey Schmalz,
who died of AIDS in 1993

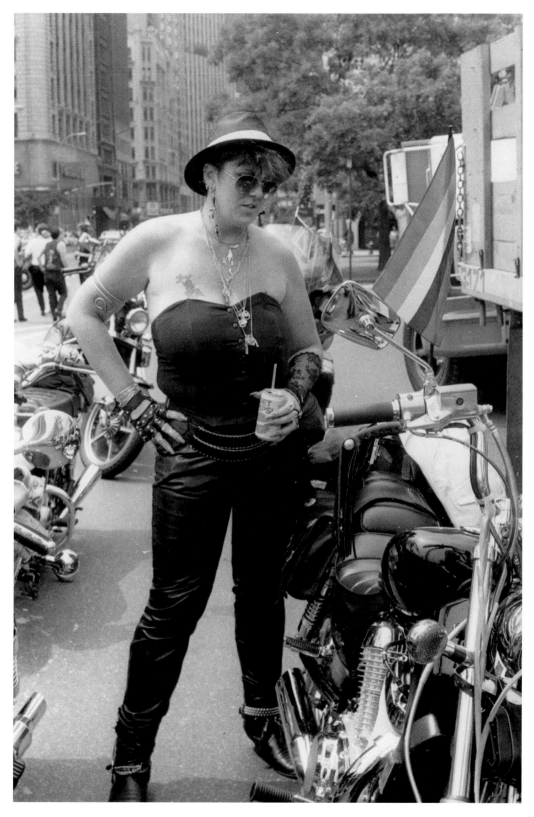

June 25, 1989.

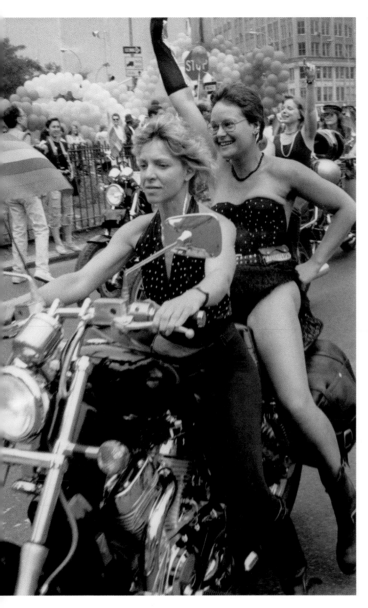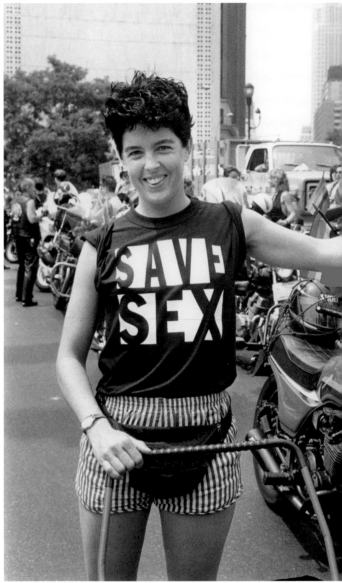

June 25, 1989.

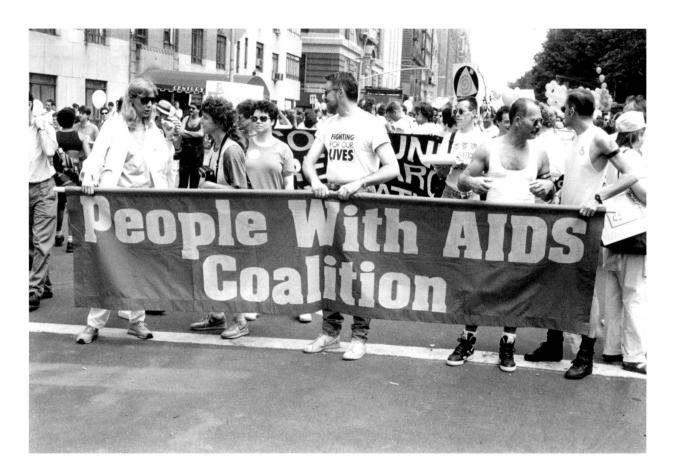

"We are leading the fight to educate the public and prevent the spread of the virus—because, until we have a cure, prevention is the only way to avert the massive human, social, and economic costs of AIDS."

—Dr. Mervyn F. Silverman, president of amfAR

People with AIDS at the Gay Rights March, June 25, 1989.

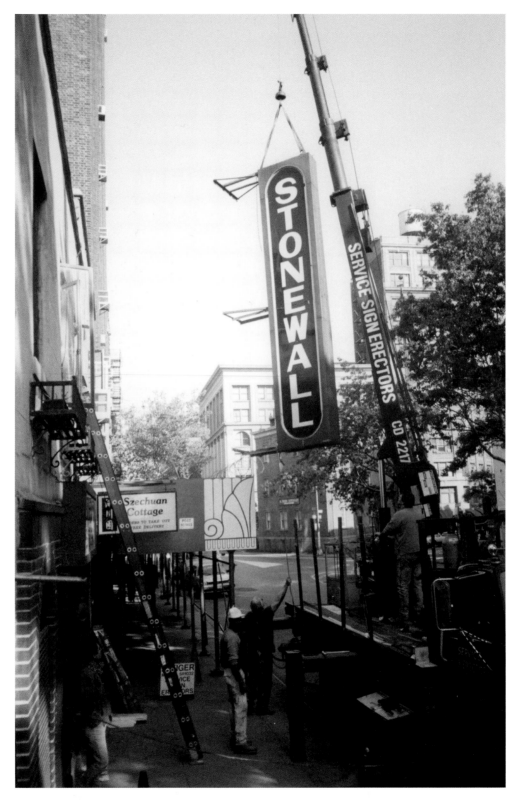

A new Stonewall was opened in the late '80s, but it closed down on October 11, 1989, when this sign was removed.

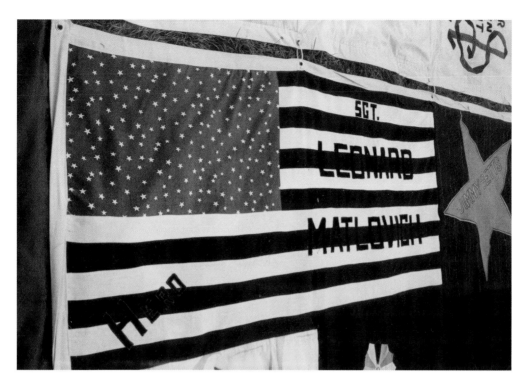

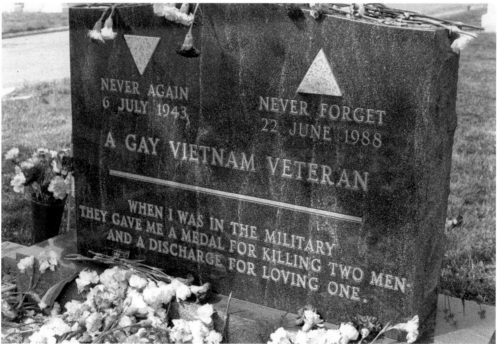

Quilt for Sergeant Leonard Matlovich displayed on the mall on October 21, 1989, as part of the NAMES Project AIDS Memorial Quilt. He also wrote his own gravestone, seen here on April 25, 1993; denied burial at Arlington National Cemetery, he was interred in the Congressional Cemetery.

Since 1984, the old P.S. 6 school building on Manhattan's West 13th Street has been home to the Lesbian, Gay, Bisexual & Transgender Community Center (formerly the Lesbian and Gay Community Services Center), delivering social, cultural, and medical services to the LGBTQ community. Approximately four hundred groups have rented space for meetings and other events, and several organizations have been headquartered there, including the Coalition for Lesbian and Gay Rights, SAGE (Senior Action in a Gay Environment), Center Kids, Lesbian Switchboard, the Pat Parker and Vito Russo Library, Youth Enrichment Services, and the Community Health Project. Act-Up, Queer Nation, and GLAAD all had their first meetings in the space. The National Museum of Lesbian and Gay History and Archive Archive (now called the LGBT National History Archive) was launched there in 1990 to produce exhibitions and provide resources for researchers.

The Center has played a large part in the transformation of the gay rights movement. "Once our enemies viewed us as weak and ineffectual. Now they characterize us as members of a rich and powerful elite, a special interest conspiracy threatening to dominate the government and media," proclaimed Richard Burns, the Center's director, on its tenth anniversary. "We need an organized, activist, broad-based community to push our agenda regardless of the prevailing political climate. That's why the Center is vital to our struggle. It builds community in so many different ways. The Center, by its very being, promotes community organizing. Many of the groups that use the Center would not exist without us."

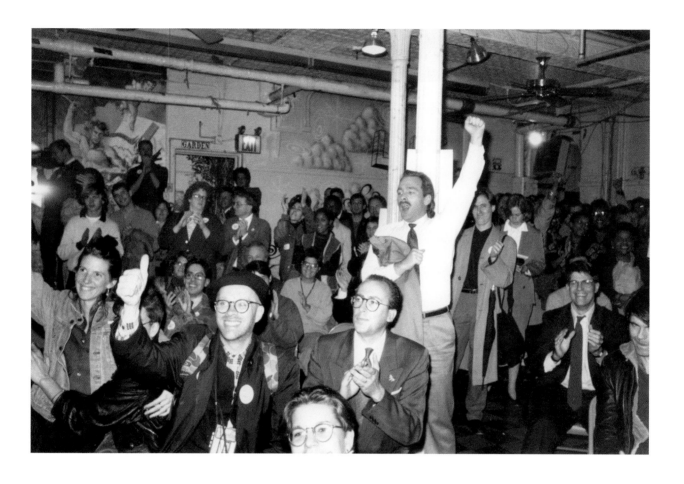

An enthusiastic crowd at the Center shouts approval during a rally for then mayoral candidate David Dinkins on November 2, 1989.

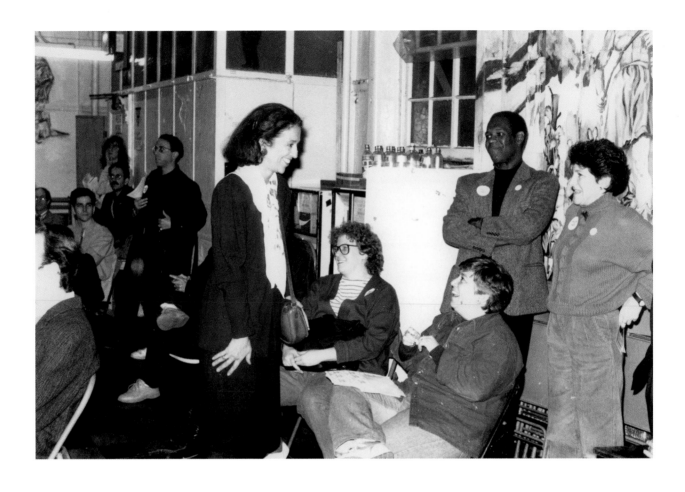

Ruth Messinger, Manhattan Borough President, at the Community Center, November 2, 1989. Her daughter Miriam came out while a student at Harvard. With Messinger are (L to R): Diane D'Alessandro, Tony Whitefield, Leslie Cagan, and Nancy Wackstein.

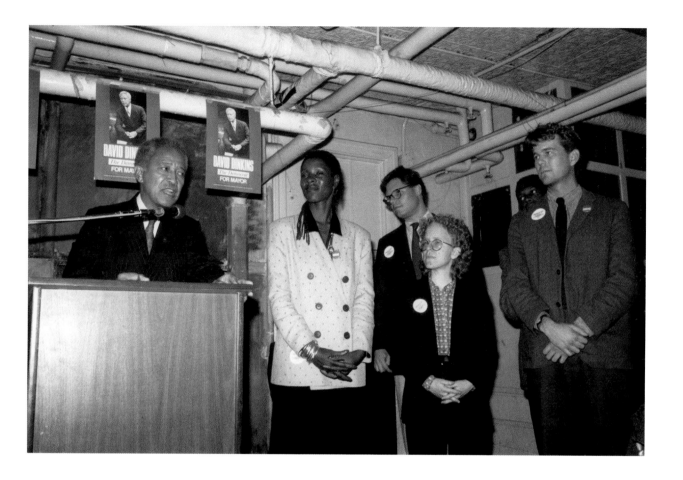

"We live in a society where differences in race, religion, culture, gender, physical ability, and sexual orientation are too often met with hostile and brutal acts. This must stop . . . The first step toward stopping it is the enactment of specific legislation declaring it to be unacceptable, illegal, a punishable crime."
—Former New York mayor David Dinkins

Campaigning at the Center, November 2, 1989, Dinkins promises to support the Domestic Partnership and Gay Rights Bill. Standing with him are (L to R): Marjorie Hill, Tom Duane, Barbara Turk, and David Kirby.

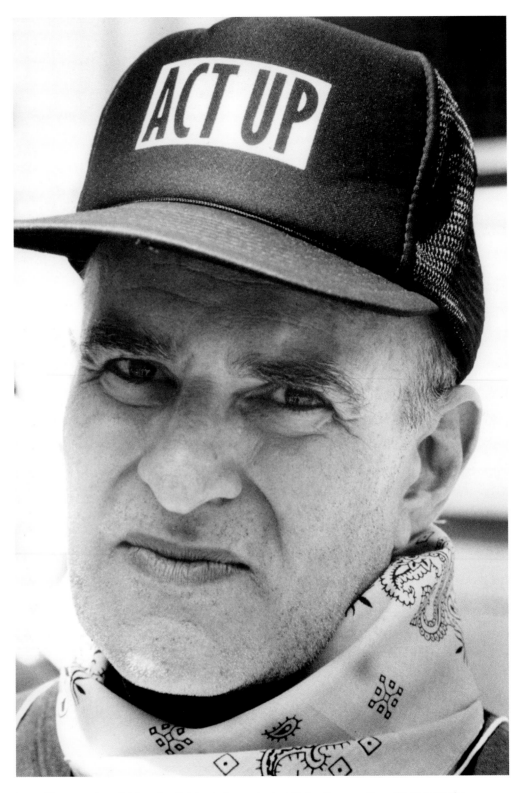

Larry Kramer, playwright and activist, photographed at Union Square at a rally to save the National Endowment for the Arts, May 15, 1990. Kramer was among the founders of Gay Men's Health Crisis and Act-Up and the author of *The Normal Heart*.

Larry Kramer, addressing a meeting of New York state doctors and health-care professionals: "I hate people like you. People who think they're so noble because you think you're taking care of the world and that makes you saints. You're all murderers. The best thing that could happen is that every single one of you quit your job and every single AIDS agency should fold up shop. That way, there'd be so many dead bodies everywhere that people like lily-livered Bill Clinton and pompous windbag Mario Cuomo would finally be unable to locate their front doors. And then maybe, just maybe, they'd finally be forced into seriously starting the research for a cure."

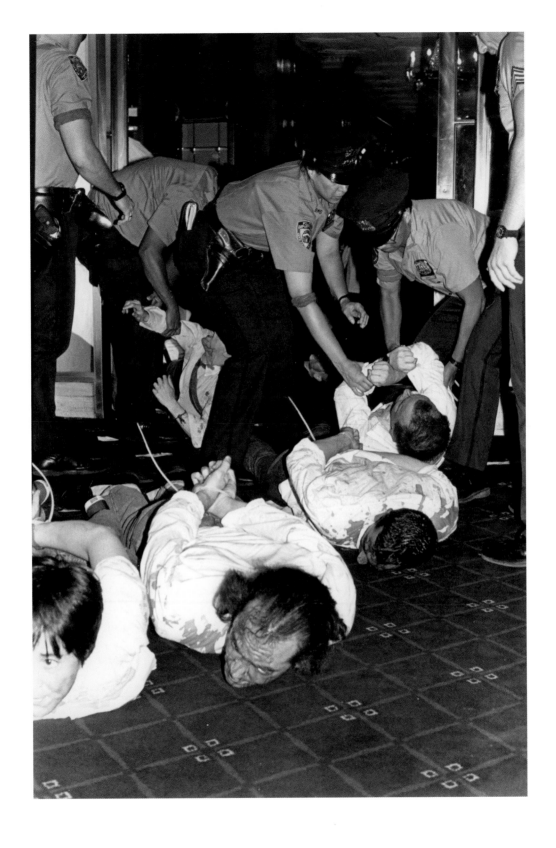

When George Bush visited the Waldorf-Astoria Hotel on August 24, 1990, Act-Up called attention to the AIDS disaster by demonstrating in the hotel lobby.

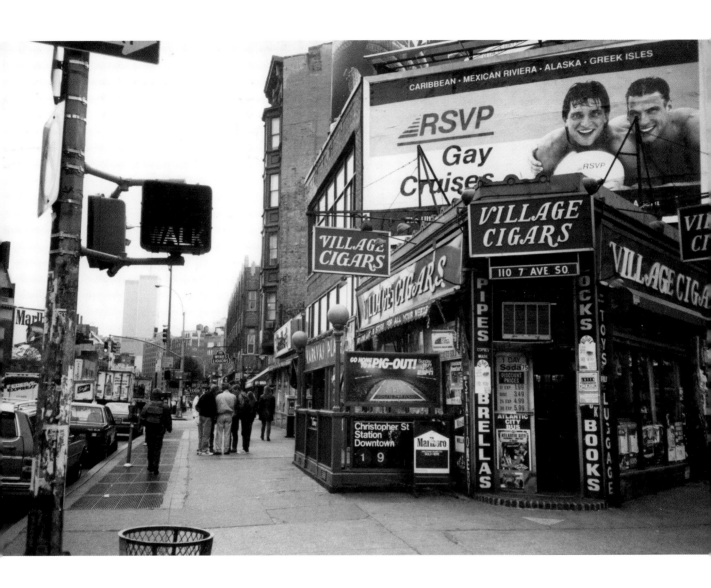

Travel agency billboard advertising gay vacation cruises, Sheridan Square, October 31, 1990.

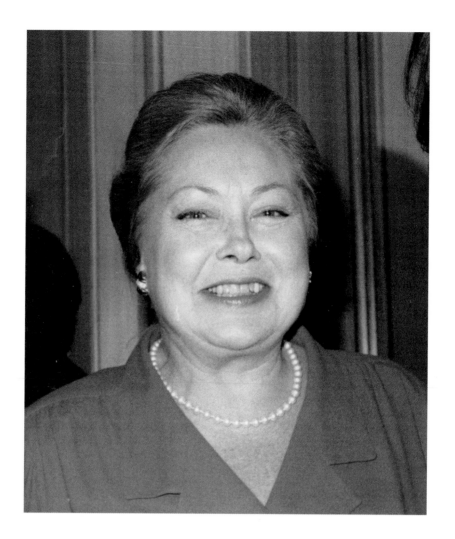

"I'm personally rather shy and retiring, and I would prefer to be ensconced in a lab. This isn't necessarily the role I'd choose to play. But I use my contacts because I do feel that it's my duty."

—Dr. Mathilde Krim, amfAR

Dr. Mathilde Krim, AIDS researcher.

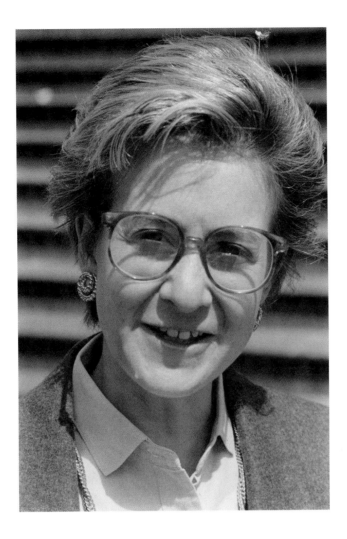

"A lot of people were really surprised to see that I am a regular person, despite my sexual orientation . . . Until my colleagues met me, I don't think they knew exactly what to expect. To some people, I will always be 'the lesbian.' You know, now that I think about it, I've really had more trouble here being a woman than a lesbian. There's a lot more sexism than homophobia in the hallowed halls of the legislature."

<div align="right">—Deborah Glick</div>

Deborah Glick, New York State Assembly Member, April 9, 1991. The first openly gay state legislator, she was reelected in 1992 with a 98 percent victory over her opponent.

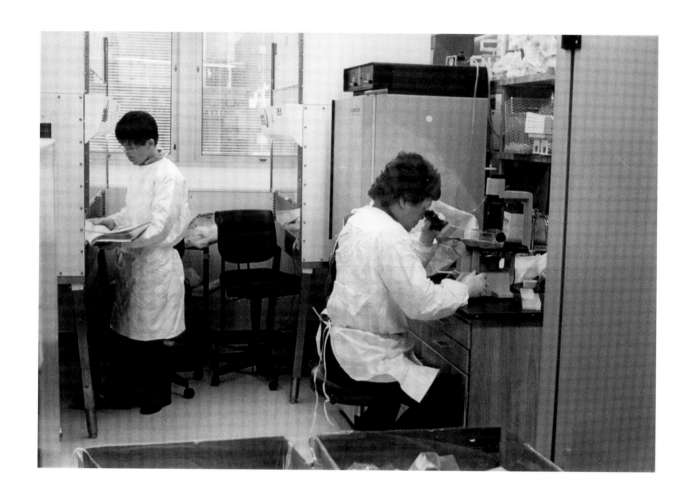

Aaron Diamond AIDS Research Center, April 16, 1991. It was one of the largest scientific facilities created to perform AIDS research, under the direction of Dr. David D. Ho, with fifty scientists and state-of-the-art research labs.

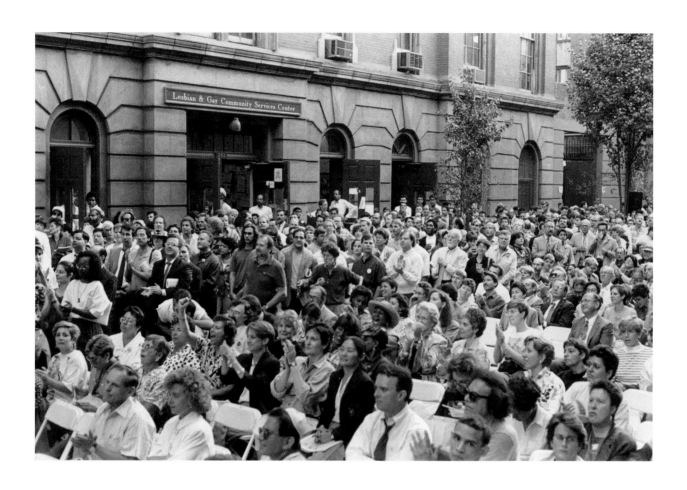

Annual Garden Party at the Lesbian and Gay Community Services Center, June 24, 1991.

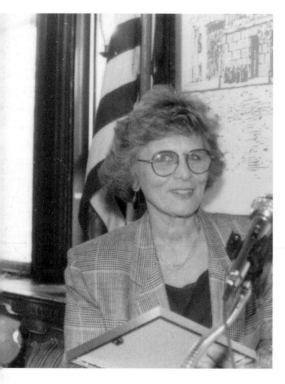

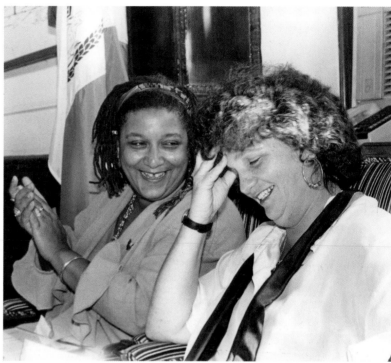

Virginia Apuzzo, former executive director, National Gay Task Force, at an awards ceremony in New York City Comptroller Liz Holtzman's office, June 26, 1991.

Essayist, poet, and novelist Jewelle Gomez and Herstory archivist Joan Nestle, at an awards ceremony in Liz Holtzman's office, June 26, 1991.

1991 March

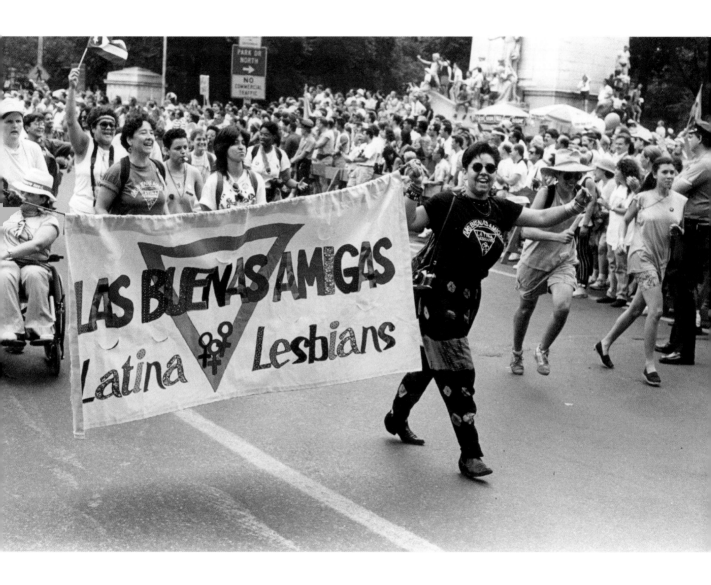

Latina Lesbians lead off the march from Columbus Circle, June 30, 1991.

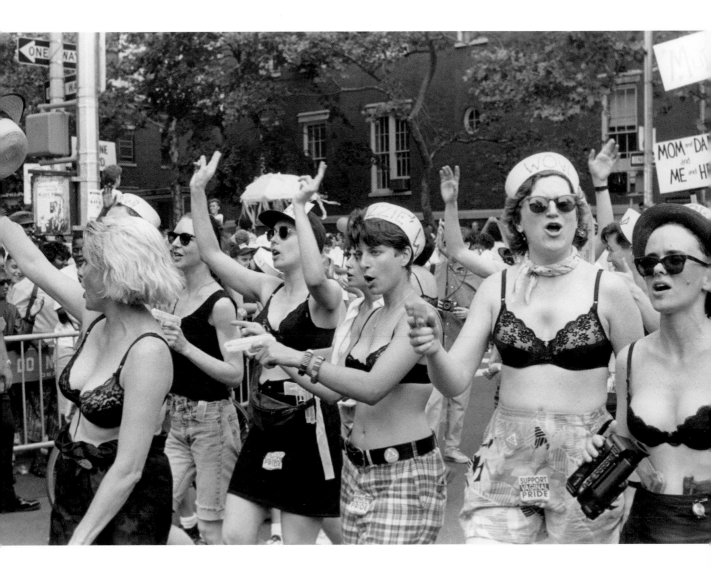

"I was playing with two little boys [when I was five years old] and they said they were going to go home to their wives. I said I was going home to my wife, too. They said 'You can't have a wife.' I said, 'Yes I can.'"

—k. d. lang

June 30, 1991.

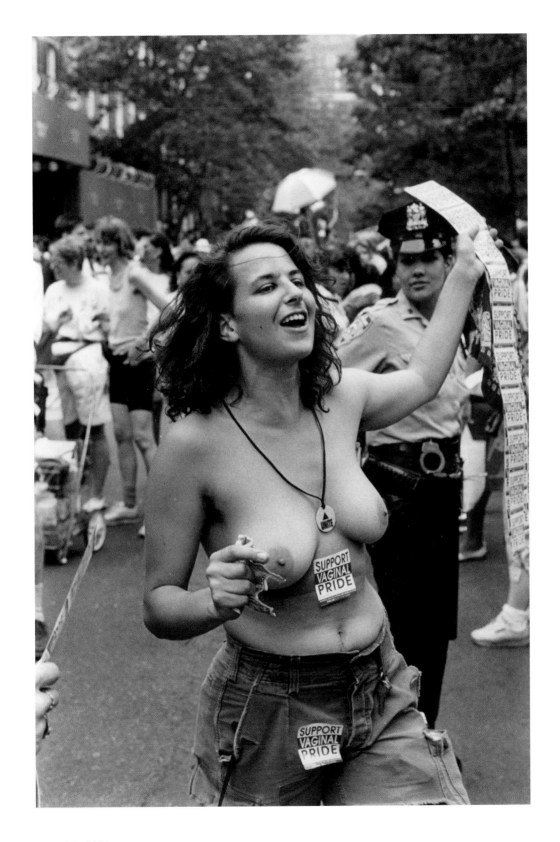

June 30, 1991.

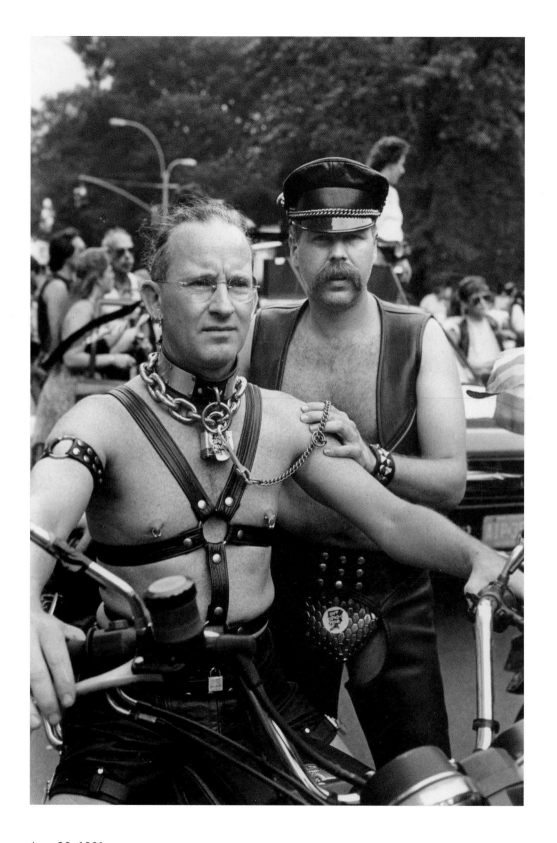

June 30, 1991.

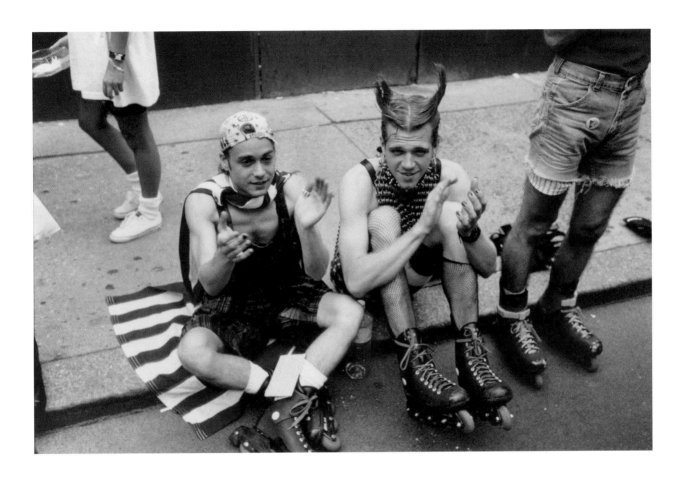

Curbs along the march route were lined with supporters. June 30, 1991.

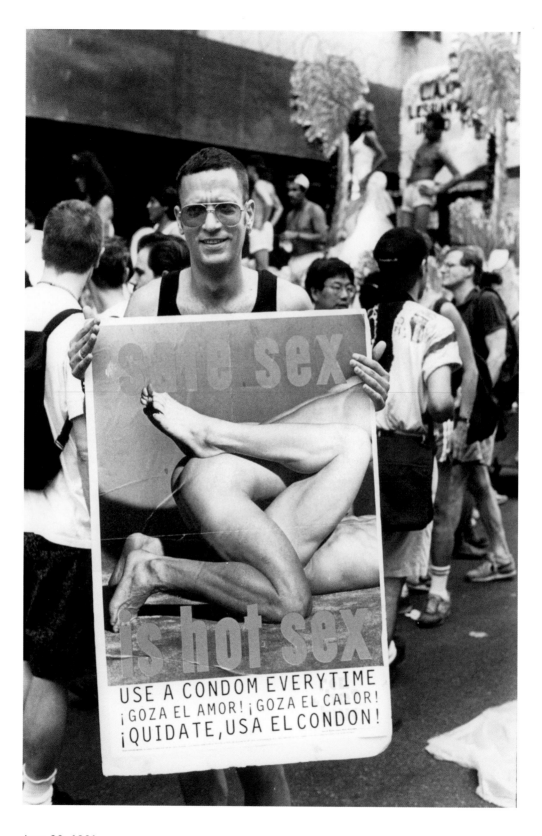

June 30, 1991.

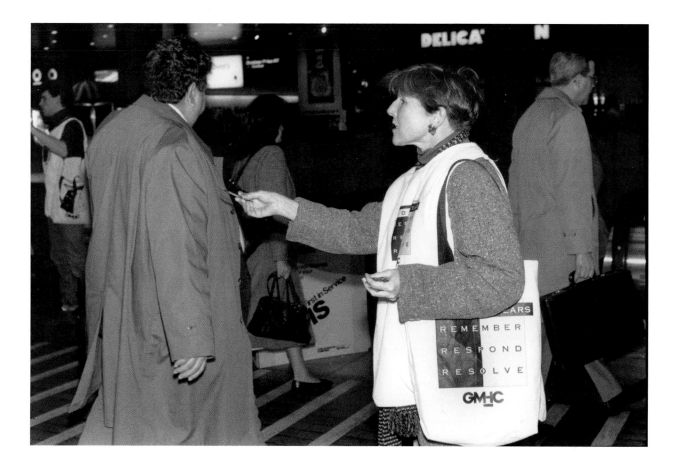

"I don't like where the gay rights movement is right now. It's so bourgeois, so middle class, so conformist. It's like a fundamentalist religion. You're not born again, you come out and live not according to Jesus, but to the gay standards. They've made sexuality the center of your being, which is not what we planned for."

<div align="right">

–Dick Leitsch

</div>

Volunteer Alice Carey from the Gay Men's Health Center handed out condoms to commuters at the World Trade Center, November 26, 1991, until security guards escorted her from the premises.

Thomas K. Duane at City Hall, January 8, 1992. Duane was the first openly gay, HIV-positive person to be elected to the New York City Council. He went on to serve in the New York State Senate from 1999 to 2012.

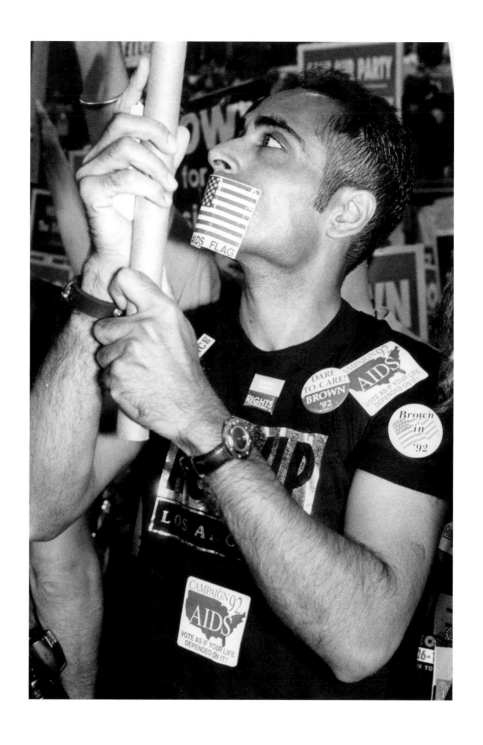

Act-Up of Los Angeles, demonstrating at the Democratic National Convention, New York City, July 15, 1992.

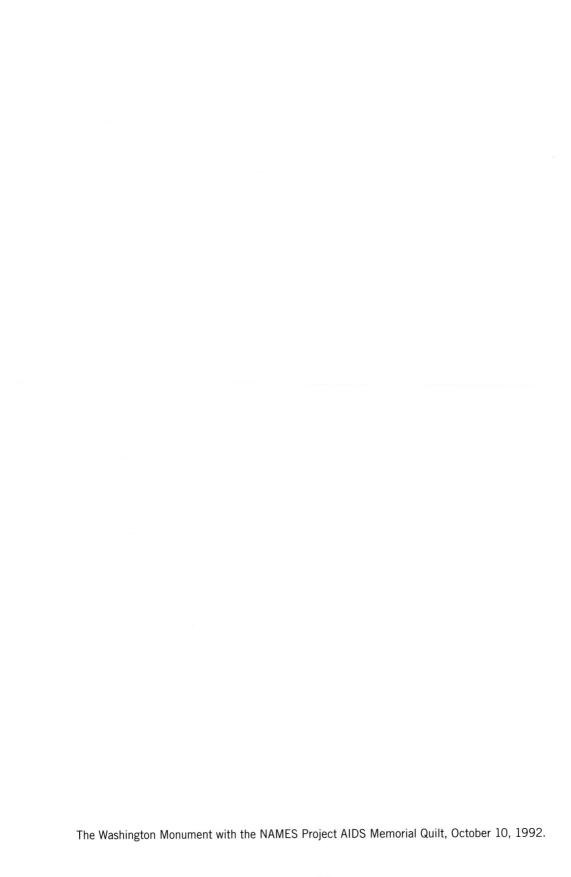

The Washington Monument with the NAMES Project AIDS Memorial Quilt, October 10, 1992.

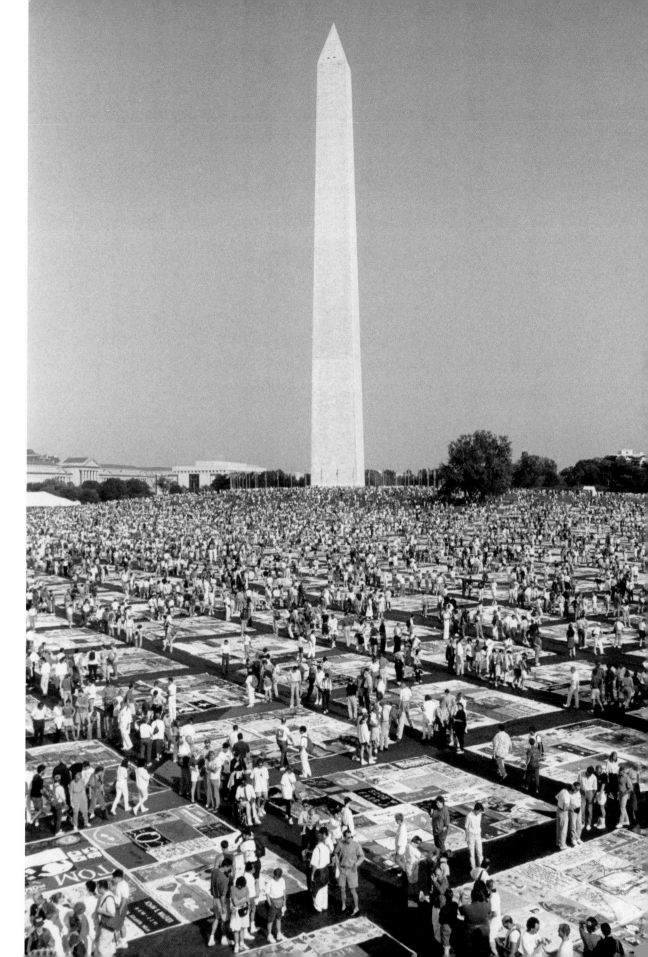

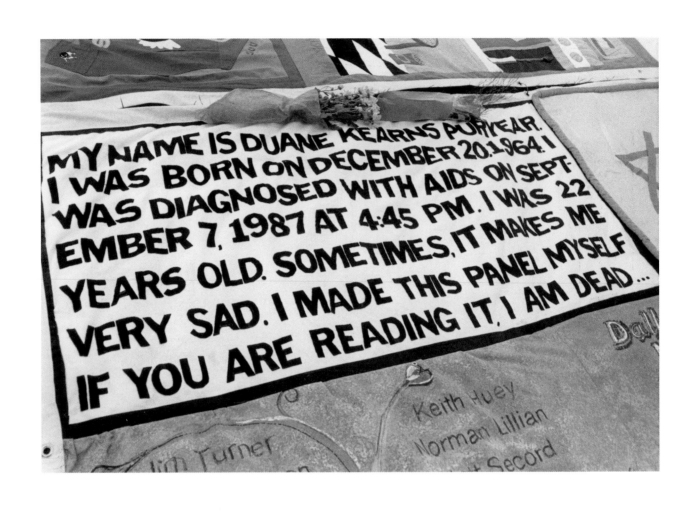

Panel of the quilt, October 10, 1992.

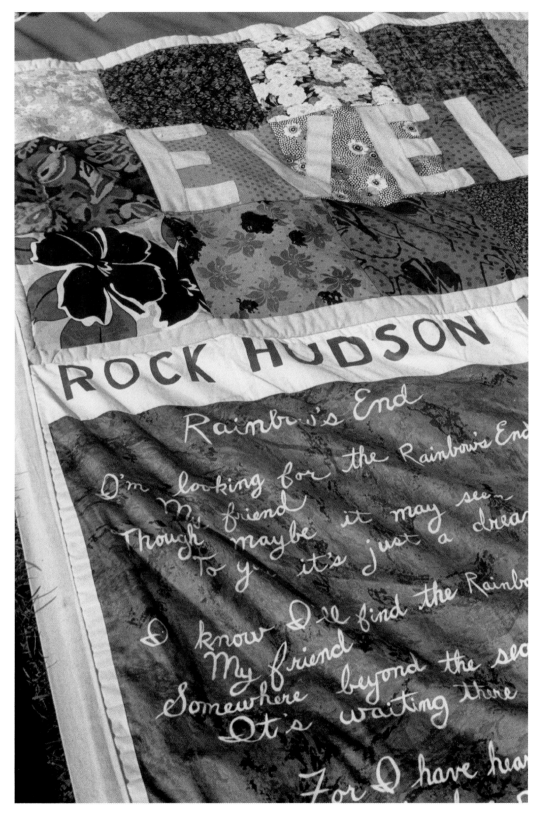

October 10, 1992. The names on the quilts include many famous figures: Rock Hudson, Michael Bennett, Perry Ellis, Robert Mapplethorpe, Keith Haring, Wayland Flowers, Liberace, Sylvester, Charles Ludlam, and Roy Cohn.

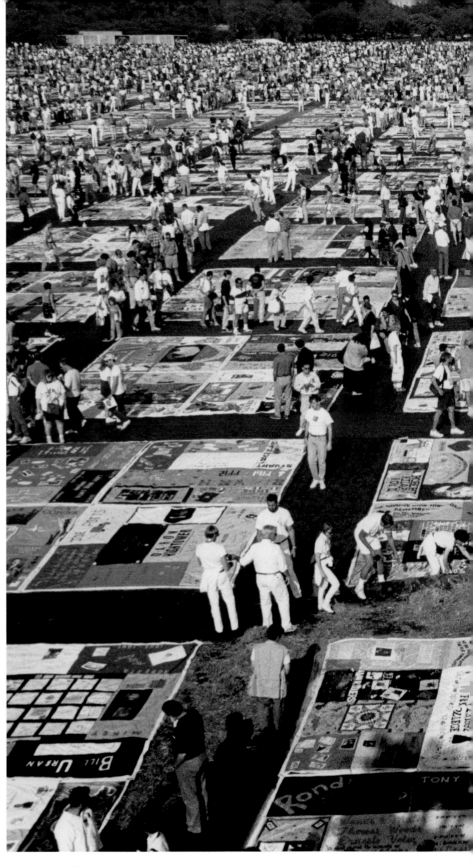

October 10, 1992.

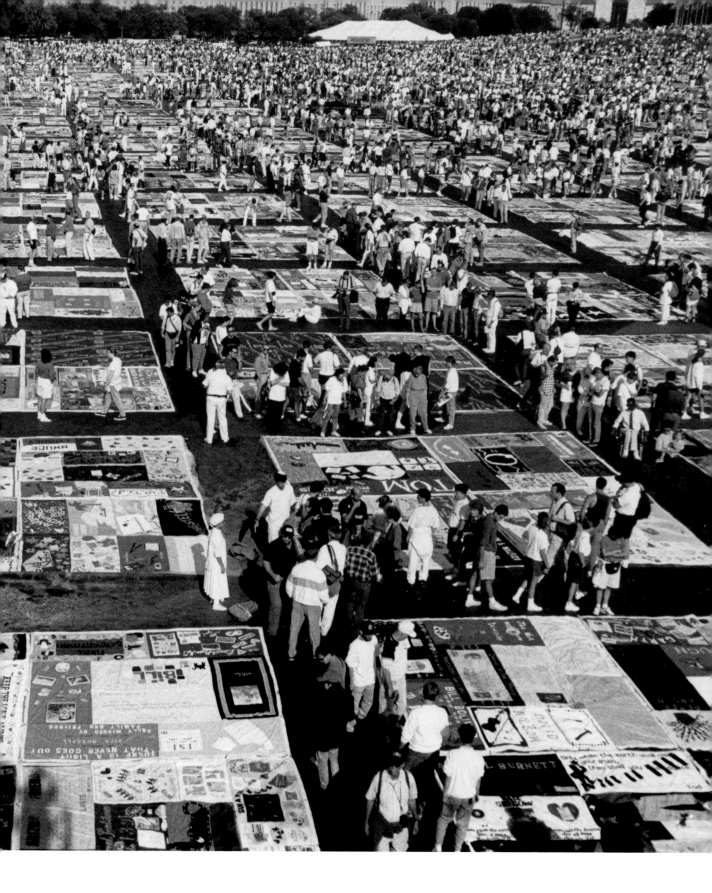

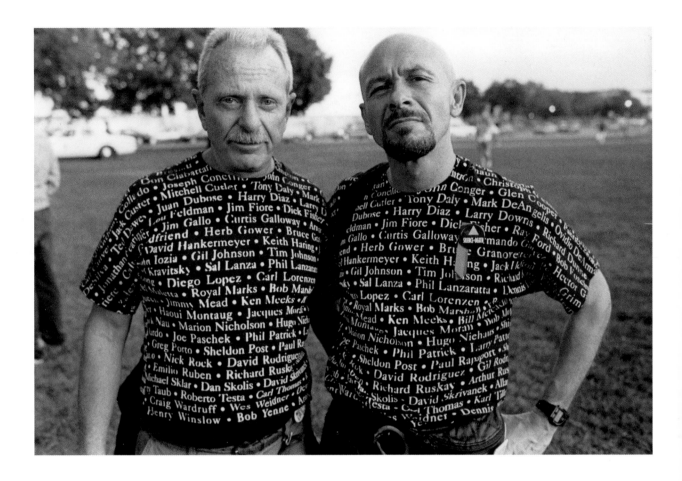

Brent Nicholson Earle and Mel Cheren, October 10, 1992. Cheren was "The Godfather of Disco," credited with inventing the twelve-inch dance single. He also founded 24 Hours for Life, a nonprofit group for AIDS education and fundraising. His partner Earle is an activist and athlete who started AREA (American Run for the End of AIDS); he ran around the entire country, covering 9,000 miles in twenty months, and raising $300,000. They made the shirts that they are wearing, showing the names of friends who died of AIDS.

On March 1, 1993, two executive orders by Mayor David Dinkins went into effect, creating a New York City registry for unmarried couples (including those of the same sex) and extending certain new rights to city employees and residents. Applying for domestic partnership status on that same day, from L to R: Gary Sechen, Wynn Miller, Fredda Rubin, and Katia Netto.

Robert Levy and David Schutte register as domestic partners, March 1, 1993.

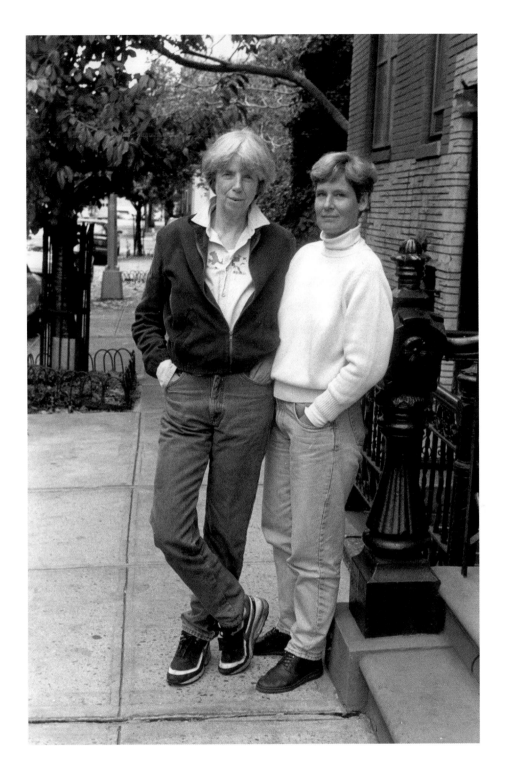

Jill Johnston and Ingrid Nyeboe, October 27, 1993. The couple married in 1993 in Denmark. Johnston said at the time, "It's really a natural thing to do and I couldn't be any happier. We've been together thirteen years. [The Danish domestic-partnership law] was the first like it in the world. It confers benefits on married partners and makes me eligible for health insurance there if I was to have a serious medical problem. I may be the first foreigner—one partner must be Danish— to marry under the new law." Johnston and Nyeboe married again, in Connecticut, in 2009.

In 1993, an estimated one million LGBTQ people and their supporters convened in the capital city.

For one weekend, the entire city was transformed into a celebration of sexuality. With panache and swagger, in leather and cashmere, in song and prayer, people came from around the world to march for their rights. And, of course, to have fun; "We're here, we're queer, so drink beer" was a common rallying cry.

But the premise of the march was serious. The weekend's platform included support for a lesbian, gay, bisexual, and transgender civil rights bill, massive increase in AIDS funding, anti-discrimination legislation, reproductive freedom, and the inclusion of nontraditional lifestyles in school curricula.

Six months earlier, the full, fifteen-acre, twenty-one-thousand-panel AIDS quilt was laid out around the Washington Monument, spreading out like a mammoth bouquet in honor of those who died of AIDS.

David Mixner, Clinton Administration advisor, April 25, 1993.

In December 1993, President Bill Clinton signed a law directing that military personnel "don't ask, don't tell, don't pursue, and don't harass" regarding sexual orientation: a policy that became known as "Don't Ask, Don't Tell" or DADT. Although it was a rhetorical rolling back of the ban on homosexual service that had been instituted during World War II, it still upheld the statutory ban. DADT was repealed under President Barack Obama in 2010, and officially ended on September 20, 2011.

"There is a tremendous amount of lesbian baiting in the military. Any straight man who propositions a woman and she's not interested, well, it can't be because he's not attractive. So it must be because she's a lesbian. It's used as a threat all the time."

<div align="right">

—Colonel Margarethe Cammermeyer,
discharged nurse, Army National Guard

</div>

Margarethe Cammermeyer, photographed April 25, 1993, was the Chief Nurse of the Washington, D.C. National Guard before being discharged for being a lesbian. A Bronze Star and Meritorious Service Medal recipient in Vietnam, she was subject to a security clearance in 1989 when she was being considered for the position. Married and the mother of four sons, she admitted that she was now a lesbian, and was "separated" from her post and rank.

"I look around and I realize: This is part of a great American tradition."
—Keith Meinhold

Petty officer Keith Meinhold, seen here at the March on Washington, April 25, 1993, was expelled from the Navy after announcing he was gay. Later, he won a court decision that led to his reinstatement.

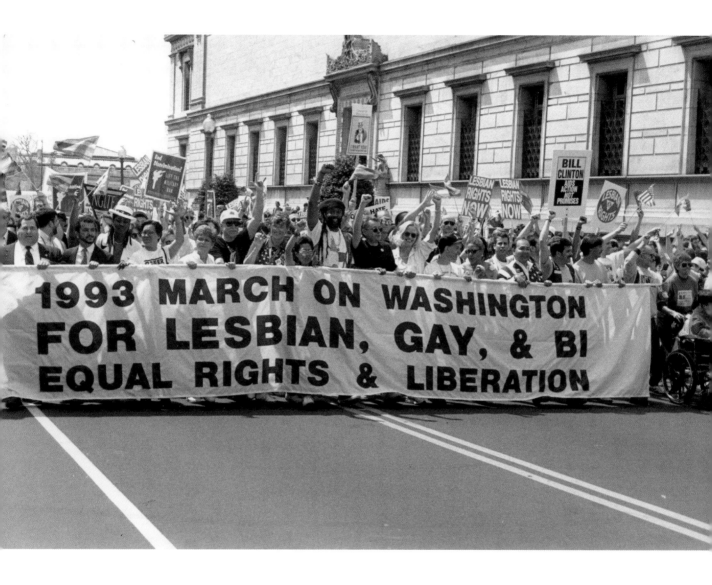

New York City Public Advocate Mark Green and Congressman Jerrold Nadler marched at the front of the line. April 25, 1993.

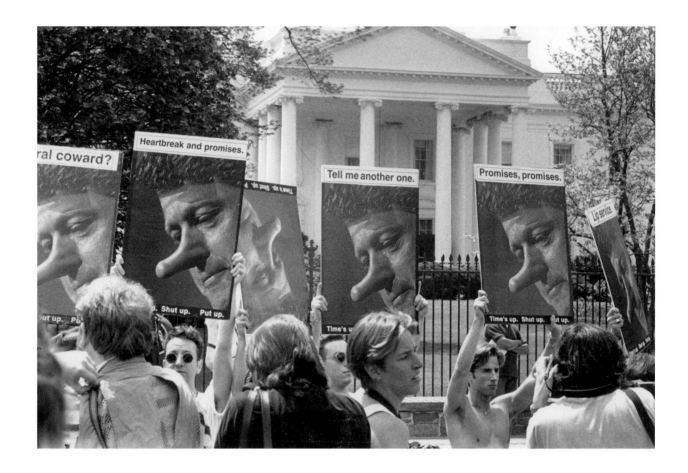

"Like Dr. Martin Luther King, who marched this same route some thirty years ago, we, too, are people with a dream."

—Reverend Donald Eastman

Act-Up demonstration outside the White House, April 25, 1993.

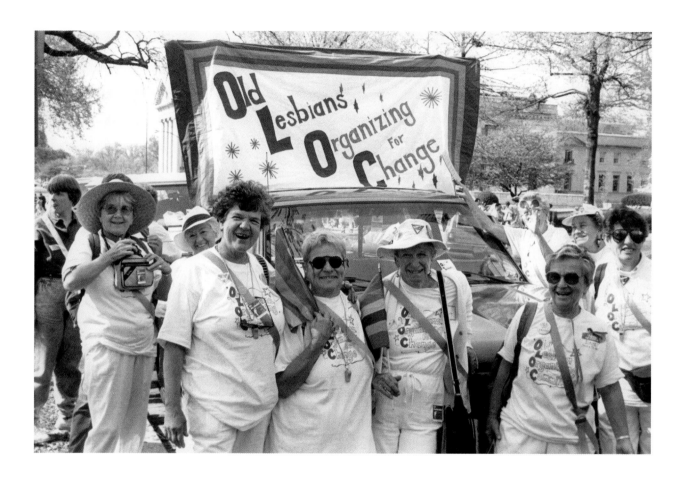

April 25, 1993.

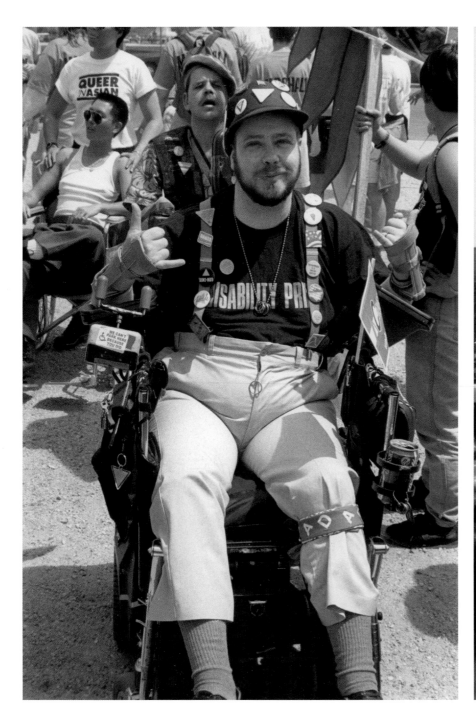

Eric von Schmetterling representing grassroots disability activist organization
ADAPT, April 25, 1993.

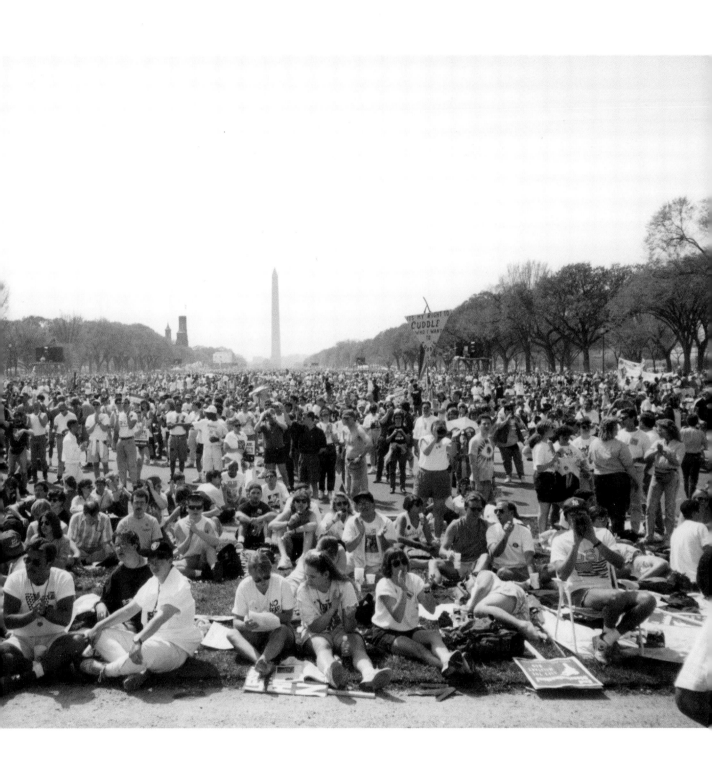

April 25, 1993.

1994 March

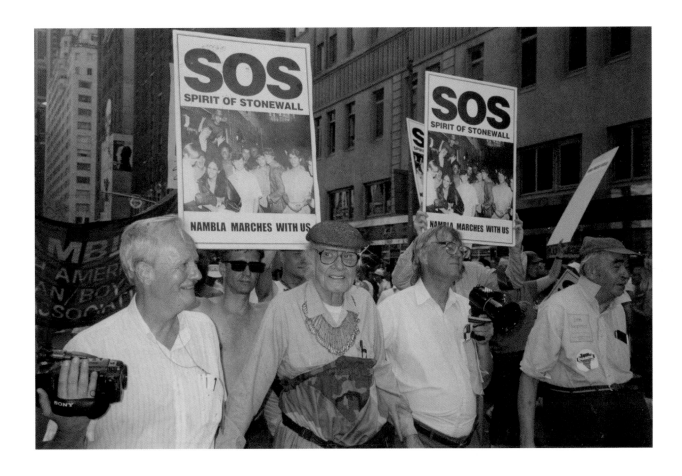

Randy Wicker (L), a participant in the 1966 Julius' Bar "Sip-In," with Harry Hay (in cap) in the 1994 parade. Hay, who has been described as the "Founder of the Modern Gay Movement," in 1948 founded the Mattachine Society. He was in a longtime relationship with designer and bikini creator Rudi Gernreich.

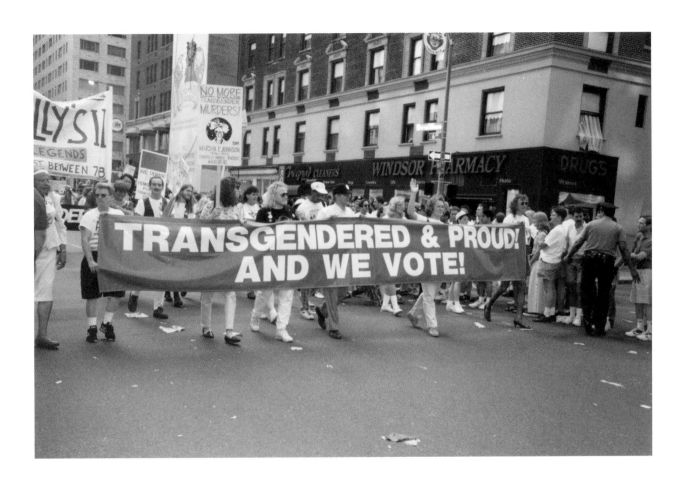

Transgender activists proudly march in the 25th anniversary parade, June 26, 1994.

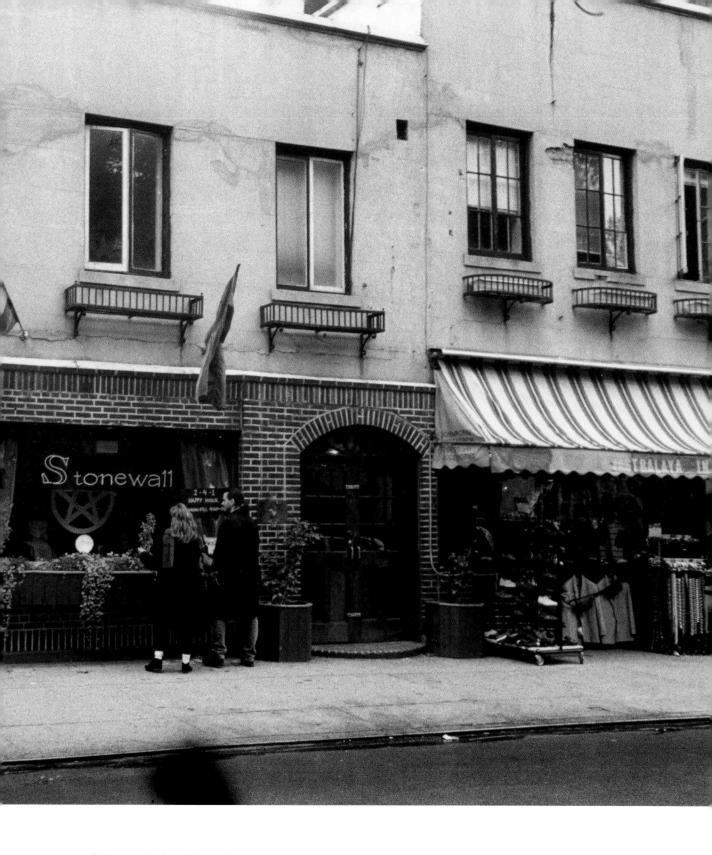

Reborn again just before this photo was taken on October 26, 1993, 53 Christopher Street enjoys its third life simply as Stonewall, with a sign in the window.

About Fred W. McDarrah

As the photographer for the *Village Voice*, the only (somewhat) mainstream media outlet on Earth paying serious and respectful attention to gay issues and events in the 1960s and 1970s, Fred W.

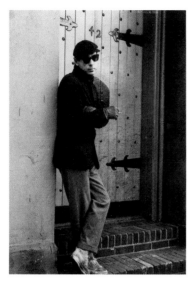

Courtesy Estate of Fred W. McDarrah

McDarrah amassed what is generally regarded as the largest collection of gay-themed documentary photos taken by one individual, ever.

Today, McDarrah images have become the signature photos of what is now inclusively referred to as LGBTQ+ history, and his photos were featured by the Barack Obama White House in the video announcing the Stonewall National Monument in 2016.

Born in Brooklyn, Fred W. McDarrah (1926–2007) bought his first camera at the 1939 World's Fair in New York City. After leaving Boys High, he served as a US Army paratrooper in Occupied Japan at the end of World War II, camera usually in hand. He earned a Journalism degree from New York University on the G.I. Bill.

He began to photograph the artists, writers, musicians and bohemian types who frequented the bars, galleries and cafes in Greenwich Village not because he was assigned to, but because he wanted to document what he felt privileged to be a witness to.

When a neighbor told Fred he was starting a newspaper—the *Voice*—McDarrah signed on. He was associated with the paper for the rest of his life. He was the paper's first picture editor, and, for decades, its only staff photographer.

McDarrah was the eyes of the *Voice*, the house organ of the postwar counterculture. His pictures were the graphic expression of the United States' first, largest, and most spirited alternative weekly as it recorded—and helped create—the most vibrant decades of the greatest city in the world.

He covered New York City's diverse downtown scenes, producing an unmatched and encyclopedic visual record of people, events, and movements, most of which were virtually ignored by the mass media at the time—including the nascent Women's Rights and Civil Rights movements, anti-Vietnam War marches, the first Earth Day, Pop Art, Beat poetry, rock music, and experimental theater. And, of course, the rise of the modern day Gay Rights movement.

Over a dozen books of his photos have been published, and his work has been exhibited at hundreds of galleries and museums around the planet, including the Museum of Modern Art, New York; the Whitney Museum of American Art, New York; Centre Georges Pompidou, Paris; Tibor de Nagy, New York; Pace, New York; and is in numerous private and public collections including the National Portrait Gallery, Washington, D.C.; the Museum of the City of New York; the J. Paul Getty Museum, Los Angeles; and the San Francisco Museum of Modern Art. Among other honors, he was the recipient of a Guggenheim Fellowship and a New York Press Club's Page One award.